CHILI QUEENS, HAY WAGONS AND FANDANGOS

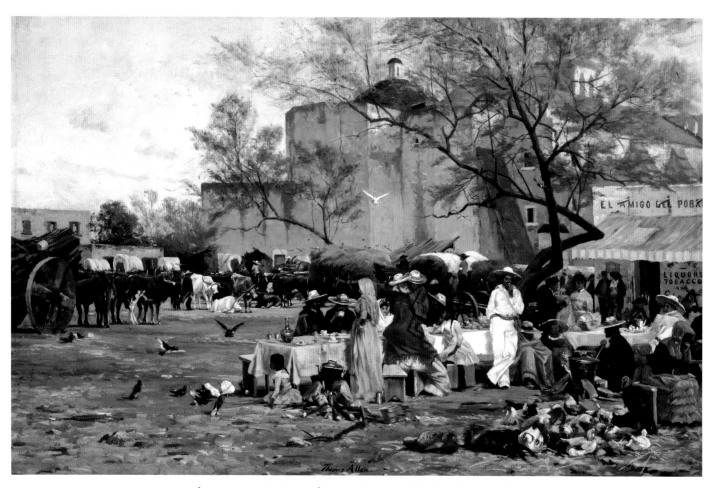

Among the iconic paintings of San Antonio is *Market Plaza* by Thomas Allen, who visited from Boston in 1878–79. The work, purchased by San Antonio's Witte Museum from Allen's family in 1936, portrays a market scene on Military Plaza behind San Fernando Cathedral.

CHILI QUEENS, HAY WAGONS AND FANDANGOS

~ The Spanish Plazas in Frontier San Antonio ~

Lewis F. Fisher

MAVERICK PUBLISHING COMPANY

MAVERICK PUBLISHING COMPANY
P.O. Box 6355, San Antonio, Texas 78209

Library of Congress Cataloging-in-Publication Data

Fisher, Lewis F.
Chili queens, hay wagons and fandangos : the Spanish plazas in frontier San Antonio / Lewis F. Fisher.
pages cm
Includes bibliographical references and index.
ISBN 978-1-893271-63-0 (alk. paper)—ISBN 978-1-893271-64-7 (alk. paper)
1. Plazas–Texas–San Antonio–History–19th century.
2. San Antonio (Tex.)–Social life and customs–19th century.
3. Frontier and pioneer life–Texas–San Antonio. I. Title.
F394.S2117F57 2013
976.4'351–dc23
2013031503

5 4 3 2 1

Printed in China

Book and jacket design by Brooks Art&Design / JanetBrooks.com

CONTENTS

PREFACE

Travel stories had been intriguing Americans with distant San Antonio for years when a railroad, in 1877, finally made the city easy to get to. Tourists began pouring in. "Many come on pleasure only for a day to peep around," sniffed a Houston newspaper, "and then go away to tell how queer it looked."

Tourists wanted images of the strange place to take back to families and friends. Photographers were already on hand, for there was much to photograph—until, by 1890, San Antonio started looking a lot like Houston and everywhere else.

In 1573, the King of Spain decreed that each new town in Spanish America be built around a central plaza. Spanish San Antonio, founded in 1718, got three: Military, Main and Alamo plazas, focal points of the community. They were already favorites of artists and illustrators when photography developed early in the second half of the nineteenth century. Thanks in part to the tourist demand for images of the picturesque city, the final years of San Antonio's frontier era—the 1870s and 1880s—were documented in dramatic visual detail.

The appeal of these photographs when shown in the richness of their original detail came clear to me when I gathered a few for a presentation on San Antonio's plazas at San Antonio's Witte Museum in 2007, at the time of its Lens on South Texas photography exhibit. Mine was one in a series on San Antonio funded in part by a grant from Humanities Texas, a state partner of the National Endowment for the Humanities, and the City of San Antonio Office of Cultural Affairs. That presentation inspired this book.

Unfortunately, no single institutional archive holds more than a fraction of the original images San Antonio's early photographers produced from their negatives. There is a multitude of copies of many of these images, but too many are blurred or lack the sharpness of the originals. My challenge was to find a broad range of original images, though many of them survive only in private collections.

A major collection of original Texas stereoviews and cabinet cards is in Fort Worth, where Southern Methodist University's DeGolyer Library has acquired the Lawrence T. Jones III Texas Photography Collection. I am grateful to Russell L. Martin III, director of the DeGolyer Library, and his staff for their assistance with the collection's San Antonio images. I am also grateful to Austin's Larry Jones for providing San Antonio images he has found since his original collection went to the DeGolyer.

Longtime Houston collector Robin Stanford merits particular thanks for her willingness to share with readers so many remarkable images that would otherwise be unseen.

For help with mining their institutions' collections I am grateful to Martha Utterback at the Daughters of the Republic of Texas Library at the Alamo, Amy Fulkerson at the Witte Museum, Beth Standifird at the San Antonio Conservation Society Library and Tom Shelton at the University of Texas at San Antonio Libraries Special Collections at the Institute of Texan Cultures. I also appreciate the assistance of, among others, Maria Watson Pfeiffer, Helen James Schupbach, Bruce MacDougal, David Haynes, Bruce Shackelford and the ever-helpful team of my wife, Mary, and our sons, William and Maverick.

INTRODUCTION

Town Plazas for New Spain

When journalist Stephen Gould produced *The Alamo City Guide* in 1882, at the top of his list for travelers was Military Plaza.

"Let us suppose the visitor arrived on a night train and went at once to his hotel," Gould wrote. "Rising at early dawn the next morning after a refreshing night's sleep he should proceed at once to the Military Plaza, and see one of the distinctive features of San Antonio, the Plaza Market."

Breakfast could come later, back at the hotel. But those "who delight in the Mexican luxuries of tamales, chili con carne, and enchiladas" would "find them here cooked in the open air" and enjoy "a genuine Mexican breakfast with as good hot coffee as can be found in the city."[1]

Gould's advice came as the frontier era was drawing to a close for San Antonio. Only five years before the city had finally been linked by rail, from the east, with the rest of the nation. Earlier, the quickest way to reach San Antonio was from a port 150 miles away on the Texas coast, a jarring ride of several days by stagecoach. Now it was a smooth journey and took only hours.

Americans had been reading about remote San Antonio in periodicals for years. With the city suddenly accessible, tourists poured in. With them came characters attracted to jumping-off points at the end of nowhere, the type who helped create other boisterous frontier towns in California, Colorado, Alaska. They added even more color to the mix of a place that had been developing in isolation for more than a century and a half.

But scarcely a decade later, by 1890, runaway growth seemed to catch up with the old ways all at once. San Antonio tipped from its helter-skelter past to become a more modern American city. Since the railroad arrived its population had nearly tripled, from 15,000 to 40,000. San Antonio, now the largest city in Texas, was no longer the end of the line. Trains arrived from every direction, not just east from Houston and New Orleans but also from California to the west, Mexico to the south and St. Louis and Chicago to the north. Within a few years of 1890, streets were finally paved, with blocks of native mesquite. Mule-drawn streetcars were replaced with cars powered by electricity. Stylish new civic buildings dominated the old plazas. Tall commercial buildings were going up as new neighborhoods spread into the countryside. Park-

like landscaping pushed vendors and wagons out of the dusty plazas, and colorful open-air markets were regulated out of existence.

Nevertheless, San Antonio's three Spanish plazas still remind the world of the distinctive evolution of this onetime outpost on the isolated frontier of New Spain.

Philip II of Spain had decreed, in 1573, that major settlements in sultry New Spain follow a basic plan, outlined in the Laws of the Indies, with a central plaza reached by a grid of streets narrow enough to block the burning rays of all but the noonday sun. Accordingly, once San Antonio's first soldiers and priests—and a handful of civilians—arrived and set up temporary quarters in 1718 near San Pedro Springs,

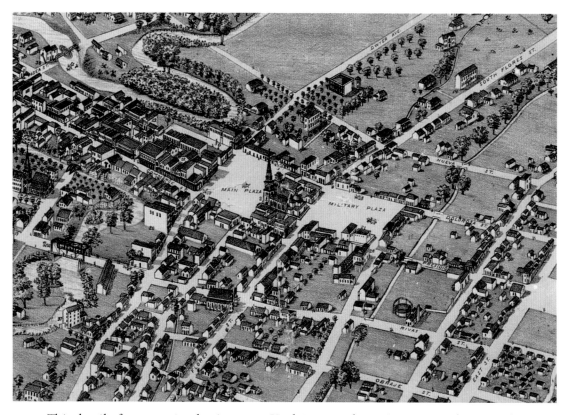

This detail of an overview by Augustus Koch in 1873 shows San Antonio's original core area around Main and Military plazas. Facing Main Plaza, San Fernando Cathedral appears with its newly finished nave and also with an anticipated steeple that was not built. Leading from the lower left of Main Plaza is Commerce Street, then the main business artery. This view is toward the southeast.

they began searching for permanent locations for a presidio and a mission. Each needed suitable access to water, proximity to tillable fields and space for a plaza. The presidio site selected was nearly two miles south, on the eastern banks of San Pedro Creek. There defenses were put up for a plaza measuring some 350 by 450 feet. Quarters for officers and soldiers were in the northern area of what became known as Plaza de Armas, or Military Plaza, near the long, low home of the presidio commander, later romanticized as the Spanish Governor's Palace.

Work also began on digging an acequia—one in a carefully engineered system of gravity-driven irrigation ditches—to supply water to the first mission, San Antonio de Valero, later known as the Alamo.

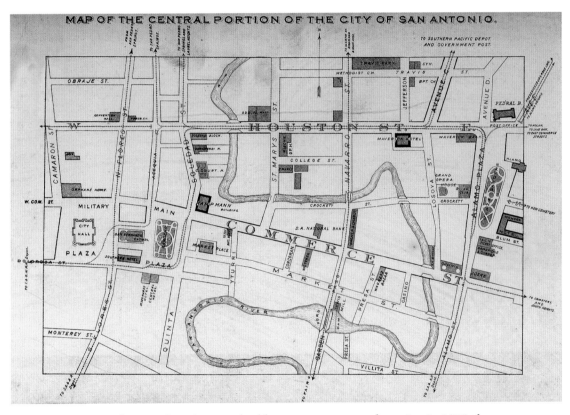

Even as frontier San Antonio had become a more modern city, in 1890 the limits of its central downtown were still defined by Military and Main plazas on the west and Alamo Plaza on the east. Military Plaza's colorful market was being displaced by a city hall rising in the plaza's center, while the dusty centers of the other two plazas are shown replaced with lush landscaping.

The mission ended up on a bluff overlooking the San Antonio River a half mile—"two gunshots"—east of Military Plaza. Its walls enclosed a traditional mission plaza, a gathering place and work area for native people being instructed in European ways of life. The natives were to be resettled in new towns on the Texas frontier as a defense against French encroachments from Louisiana.

The last component of Spanish colonial San Antonio fell into place in 1731, when the military and mission communities were joined by a significant group of civilian settlers, fifty-six immigrants from the Canary Islands. They were housed in the presidio until a site for their new Villa of San Fernando de Béxar could be set up. The civilians' plaza was to be on the far side of San Pedro Creek, "a gunshot's distance. . . to

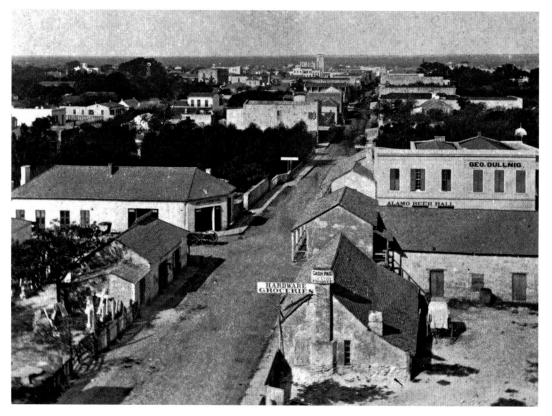

This late 1870s view from just south of Alamo Plaza looks down Commerce Street over the trees lining the San Antonio River toward Main Plaza, dominated by San Fernando Cathedral and the first of its soon-to-be-two new towers at right center in the distance.

the west of the presidio." That area, however, was deemed too flat to be irrigated. The site finally chosen for the civilian plaza was quite close to Military Plaza, just to its east, and slightly larger. The two plazas would be separated by a narrow row of buildings hardly deeper than the new parish church of San Fernando. The front of the church would face the new plaza—La Plaza de las Islas/Plaza Mayor, eventually known as Main Plaza—and its apse would back on Military Plaza. A key to the plaza's location was finding a line of gravity that could support the flow of water in an acequia from San Pedro Springs down through the plaza, providing water to irrigate fields along the way. The San Pedro Acequia was in use by 1735.[2]

San Antonio did not develop as precisely as Spanish imperial policy would have had it. Rather than following a pure grid, outlying streets were strung with ramshackle buildings and often meandered along the paths of various acequias, lending a sense of disorder. By the 1770s its residents lived, according to the visiting missionary Juan Agustín Morfi, in "fifty-nine houses of stone and mud and seventy-nine of wood, but all poorly built." The place resembled "more a poor village than a villa. . . . The streets are tortuous, and filled with mud when it rains."

Nevertheless, San Antonio became home to 2,000 people, until the political chaos and military conflicts of the early nineteenth century reduced the number to 800. Once the Mexican War finally decided the matter of annexation of Texas by the United States, fear of more invasions from south of the Rio Grande dissipated, and the situation reversed. By 1850 there were nearly 3,500 San Antonians. Immigrants from other states and from across Europe added vibrancy to the remote place. German became the most frequently spoken language. San Antonio's appearance grew ever more unusual as two-story buildings in imported architectural styles in native limestone—the primary building material available—mixed with the earlier low structures of stone, mud and wood. Frederick Law Olmsted, traveling through in 1856, two years before beginning work on the design of New York's Central Park, wrote of San Antonio's "jumble of races, costumes, languages and buildings," and concluded that only New Orleans could compare with San Antonio in its "odd and antiquated foreignness."

Frontier violence was no stranger, with frequent shootings and the occasional hanging. Olmsted found that "murders, from avarice or revenge, are common." He added that "more often than otherwise, the parties meet upon the plaza by chance and each, on catching sight of his enemy, draws a revolver and fires away. As the actors are under more or less excitement, their aim is not apt to be of the most careful and sure, consequently it is, not seldom, the passers-by who suffer. . . After disposing of all their lead, . . . if neither is seriously injured, they are brought to drink together on the following day, and the town waits for the next excitement."[3]

Adding variety to the plazas were immigrant Mexican families who lived nearby and denizens of the thriving red-light district west of San Pedro Creek. These mixed with staid citizens, soldiers, visiting cow-

hands, bird sellers, tamale vendors, wood merchants and saloon keepers in an other-worldly setting that proved irresistible to the incoming tide of tourists.

Travelers wanted some way to help remember the place. Artists—Theodore Gentilz, Thomas Allen, William Samuel and others—had been painting and sketching the scene for decades, but their work was hard to come by. By 1890, when San Antonio's trappings as a frontier town were fast disappearing, hand-held cameras were still a decade or more away, picture postcards further still. In place, however, were professional San Antonio photographers, ready to sell photographs of exotic sights to be carried home.

More than a hundred photographers have been identified as being in San Antonio at some point during the nineteenth century. Of these, more than a dozen went beyond studio photography to document the San Antonio scene. Some, like Prussian-born Henry Doerr, had been photographing San Antonio since the 1860s. Others, like Doerr's fellow countryman Nicholas Winther and Henry Bingham, down from Michigan, had been in town for almost as long.[4]

The photographers were burdened with cumbersome equipment. Their heavy, wooden-cased cameras had to be set on tripods. Telephoto lenses could draw foregrounds in too closely and compress distances. Wider views had deceptive distortions at the edges. Glass negatives required careful handling and developing—and could not record views in low light or at night, and their slow exposure made photographing complex scenes difficult. A moving horse-drawn cart caused an ill-defined streak across an image. Smoke from cooking fires left overly long blurs, and a vegetable vendor could turn so quickly as to register no detail at all, appearing invisible to the viewer. Still, these photographers left a legacy of extraordinary images of frontier San Antonio, particularly of the plazas so popular with tourists.

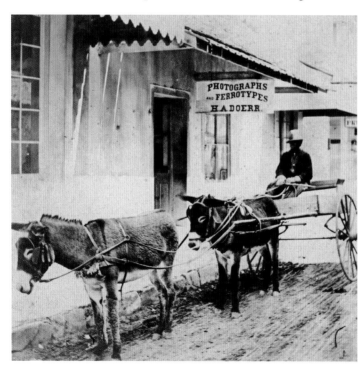

Pioneer San Antonio photographer Henry A. Doerr took this view of a wagon drawn by a team of two burros in front of his early Commerce Street studio. He advertised photographs and ferrotypes, better known as tintypes.

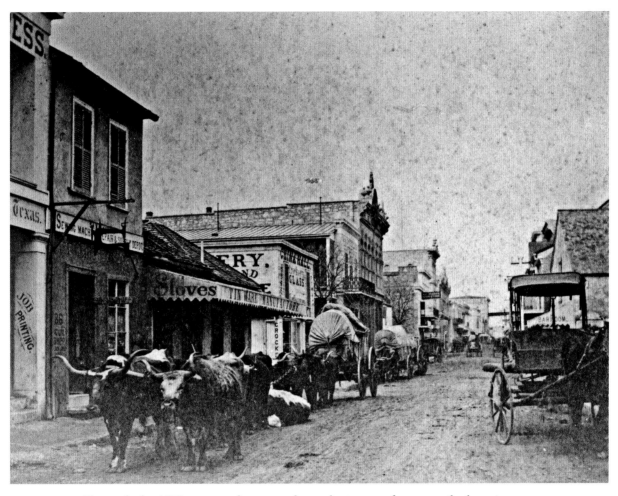

Through the 1870s, covered wagons drawn by teams of oxen on the long journey from the Texas coast often headed up Commerce Street to Main and Military plazas. Extending into the street above the ox at left is the symbol of a sewing machine, announcing the location of the Sewing Machine & Supply Depot. At the far left is the edge of the building of San Antonio's German language newspaper, *Die Freie Presse für Texas*.

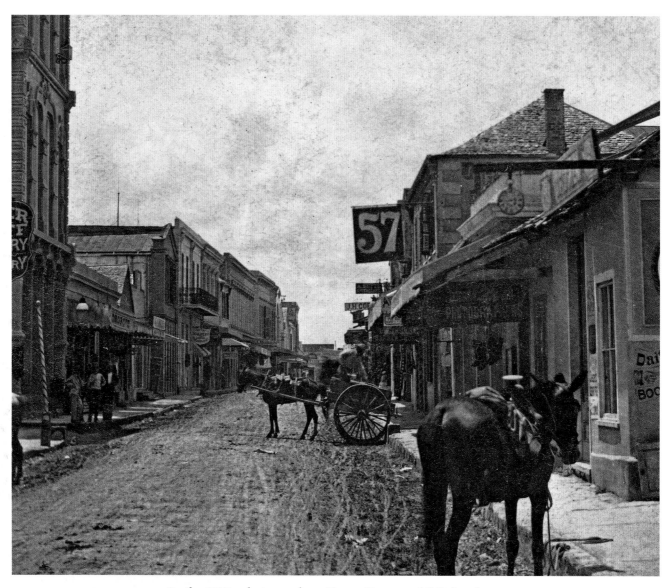

In the 1870s photographers Henry Doerr and S.E. Jacobson shared an office at 63 West Commerce Street, not far from Main Plaza. Their sign hangs center right.

On the back of a stereoview marked "Fruit Stand," Frank Hardesty advertised his willingness to take pictures "anywhere" for customers.

Double-image cards for hand-held three-dimensional viewing were in vogue, but their individual images were small, little more than three inches square.

Photographer Frank Hardesty made a specialty of single-image cabinet cards, their mounted views more than four by seven inches, better for studying scenes more closely. In the early 1880s, while still in his late twenties, Hardesty set up shop in a canvas building a half block north of Military Plaza, and lived at the back. He was conveniently close to sightseers and aimed straight at the tourist market. No rooftop seemed too high for him to lug up his camera for a vista, no scene too mundane to capture through his lens.

Frank Hardesty named his operation the San Antonio View Company. If a visitor wanted something special, he would do "views made to order anywhere." He cataloged subjects on the backs of cabinet cards that bore his images, advertised a selection of some 300 different local scenes and provided them for sale by the dozen. He claimed his was none other than the "largest collection of fine stereoscopic views in Texas." But as San Antonio was changing, the unusual scenes he photographed were also disappearing. In 1889, Hardesty, at the age of thirty-five, sold his studio to protégé Asa Brack and moved on to opportunities in even faster-growing Los Angeles, where he remained in the photography business well into his seventies.[5]

These painters, illustrators and photographers left us with memorable images of the evolution of a remarkable city and a pivotal era, its frontier essence no better displayed than on the plazas laid out in San Antonio's earliest years in the northern reaches of New Spain.

◆ I ◆
MILITARY PLAZA

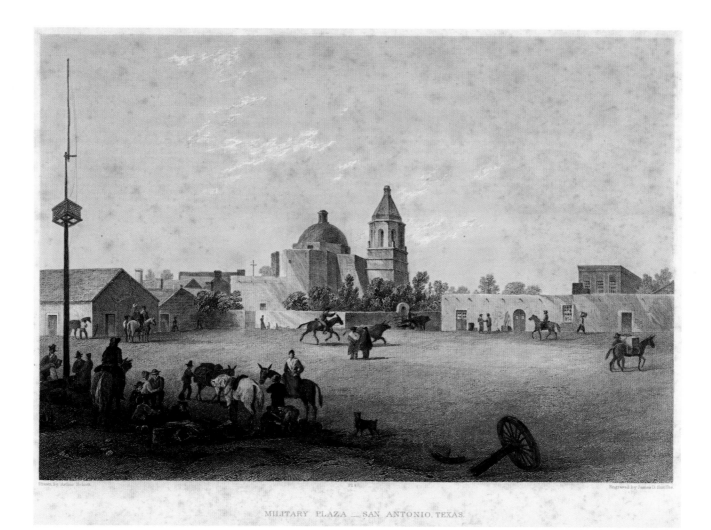

MILITARY PLAZA — SAN ANTONIO. TEXAS.

Military Plaza was the subject of this steel engraving by James Simillie from a drawing in 1853 by Arthur Schott, one of many artists who improved on the awkward appearance of the Church of San Fernando's original tower.

1. Garrison Ground to Playground

Military Plaza in the 1870s and 80s was a swirl of clattering wagons, bird sellers and vegetable vendors, cowboys in from trail drives, bargain hunters, raucous saloons, rickety tables of fast foods. There was commotion from all quarters. "Amidst all the fanfare and high jinks," recalled one eyewitness, could suddenly appear "a country wagon filled with poultry, uncomfortably trying to roost in such quarters and much disturbed by the unseemly noises. It was the chicken peddler's outfit."[1]

At night, odors from kerosene lamps and tin lanterns mixed with the fragrance of burning mesquite beneath pots and skillets sending up aromas of cooking chili and frijoles. In the shadows, rebozo-draped chili queens served all manner of diners lining benches beside the oilcloth-covered tables that stretched into the plaza.

The scene was not unlike those at open-air markets elsewhere in the world, though it had the unusual overlay of the Old West and stood apart from other markets in the United States. It was a peculiar setting to bear the name "Military Plaza." The name would still seem odd a decade later, when a hulking new city hall dominated the plaza. But the square's original name, Plaza de Armas—in translation, Military Plaza—has stuck from the earliest days of San Antonio, when it was, indeed, meant only for soldiers.

Fire in December 1721 burned sixteen of the frame and mud homes of the newly garrisoned presidio of San Antonio de Béxar just south of San Pedro Springs and destroyed the granary with the winter food supply. A contingent of Spanish soldiers and priests had settled at the spot hardly three and a half years before to establish the presidio and a mission as a way station between the Rio Grande and East Texas, where a few Spanish missions and military outposts managed to buffer the sparsely settled frontier against the French in Louisiana.

Rather than rebuild, officials abandoned the area for a site downstream just over a mile south. There new single-story stone buildings edged a presidio with a central plaza. By early 1731 there were perhaps forty houses near the presidio. The population was estimated at 235, including two dozen civilian families plus families of forty-four officers and soldiers. The home of the presidio commander, restored as the Spanish Governor's Palace, is the only surviving example of eighteenth-century Spanish residential architecture in Texas. Carved into its entry keystone is the date 1749, during the command of Toribio de Urrutia.[2]

Later in 1731 immigrants arriving from the Canary Islands found homes in the presidio until nearby Main Plaza was ready for them. The civilian, military and mission communities struggled in isolation with conflicting lines of authority and scarce resources. Nevertheless, San Antonio managed to grow to 2,000

near the end of its first century, before being decimated by political and military upheavals. U.S. Army Capt. Zebulon Pike was reconnoitering northern New Spain and had lately tried to climb what became known as Pike's Peak when he passed through San Antonio in 1807. He found a pervasive festival spirit. Where else, he wondered, could one find the governor, a revered figure during the day, dancing at night in the plaza with his people?[3]

Four years later, however, came a gruesome foreshadowing of the chaos that would soon plague San Antonio and Texas. When the royalist Spanish governor of Texas arrived in San Antonio in 1811 during a revolt against Spanish authority, rebellious soldiers under Capt. Juan Bautista de las Casas arrested the

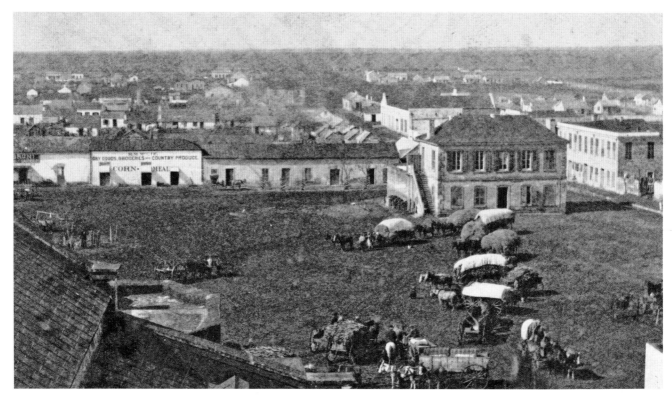

San Antonio's elegant Georgian-style city hall, right center, was built at the northwest corner of Military Plaza in 1850-51. The building became known as the Bat Cave for the number of bats that roosted in its eaves and walls. This view looks west from the tower of San Fernando Cathedral in about 1873. Facing the plaza in the center is the 1740s home of the presidio commander, now restored as the Spanish Governor's Palace.

governor. After six tumultuous weeks, a royalist force arrived, arrested Casas and took him to Monclova for court-martial. Casas was shot in the back and beheaded. His body was buried at Monclova. His head, as an example to revolutionaries, was returned to San Antonio and hung from a pole in the middle of Military Plaza.[4]

The following three decades brought a series of invasions and overthrows. There was fighting on the plaza during the Siege of Bexar in 1835, when a Mexican Army was routed only to return the next year for battle at the Alamo. All was settled when the Mexican War ended in 1848, and stability returned to San Antonio and Texas. The U.S. Army rejected Military Plaza as a base and chose quarters elsewhere. Small private homes had been going up on the plaza since the 1820s. Its transition to civilian use was now complete.

To city officials looking for a new home, public land inside the northwestern corner of Military Plaza seemed a fine location. Spanish urban planners of old may have wanted the plaza to be completely open, but it wasn't, for there were already several buildings—including onetime Spanish Army officers' quarters—within its northeastern corner. Thus was a two-story city hall and courthouse, with an adjoining jail inside a walled enclosure, built at the corner in 1850–51. Its sophisticated Georgian design is attributed to the city's leading architect, John Fries, who created the Alamo's signature gabled parapet for the U.S. Army about the same time. Bats roosting in the eaves and walls swept across the plaza at night and occasionally got into the district courtroom upstairs, causing the structure to go down in history as the Bat Cave.[5]

Military Plaza became a sort of municipal playground. There were fandangos, cockfights, bullfights. In 1852 a circus company put up a tent on Military Plaza for performances that included the appearance of a two-headed cow. Small bars or *cantinas* began springing up, serving newcomers as well as vendors who had been selling food and fruit on the plaza since the days of Spanish soldiers. City officials tried promoting some sense of order and quiet in their new neighborhood by restricting the vendors to nighttimes and holidays. They met with little success, as demand for quick meals picked up with the increasing numbers of freight wagons arriving from the coast to converge on Military Plaza or regroup in wagon yards nearby.[6]

Visiting cowboys created their own entertainment. Finding an open spot on the plaza, those on ponies would "toss coins to the ground and ride away a little distance to gain momentum on their return. Then, yelling like Indians, the riders would swoop down on the coins and pick them up while hanging by one leg to the saddle. They were so expert that they seldom failed to accomplish the trick."[7]

A writer, Richard Everett, passed through in September 1858 with a mule-drawn wagon train bound for silver mines in Arizona. "After twelve days of slow travel across the prairies from the sea coast, meeting with very sparse evidences of civilization, San Antonio appeared to us like the Mecca of some wearied caravan," Everett reported in New York-based *Frank Leslie's Illustrated Newspaper*. He described the place as

"like Quebec, a city of the olden time, jostled and crowded by modern enterprise. . . . Walking about the city and its environs you may well fancy yourself in some strange land."

Apart from the industriousness of a minority of "respectable, intelligent and wealthy families," Everett sensed a colorful "free-and-easy style of life which is. . . sure to surprise a stranger." He described the fandango, a sometimes unruly public dance held, among other places, on Military Plaza:

> A large hall or square room, lighted by a few lamps hung from the walls or lanterns suspended from the ceilings, a pair of negro fiddlers and twenty or thirty couples in the full enjoyment of a 'bolero,' or the Mexican polka, help make up the scene. In the corners of the room are refreshment tables, under the charge of old women, where coffee, frijoles, tortillas, boiled rice and other eatables may be obtained, whiskey being nominally not sold. From the brawls and free fights which often take place, it is surmised that the article may be had in some mysterious manner.

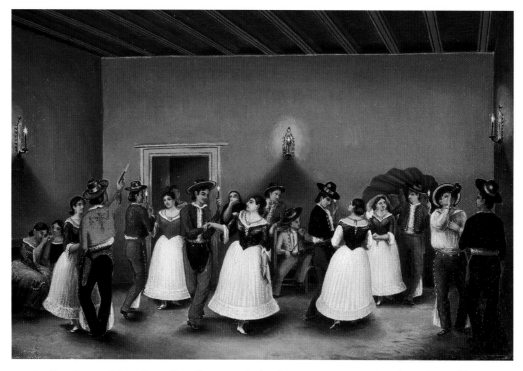

In *Fandango*, Theodore Gentilz recorded a dance in a Spanish colonial residence on Military Plaza in the 1840s, complete with a pistol firing and one party-goer drinking from a bottle. Candles in the left hands of the dancers is a custom reportedly still practiced in some dances on Mexico's Yucatán Peninsula.

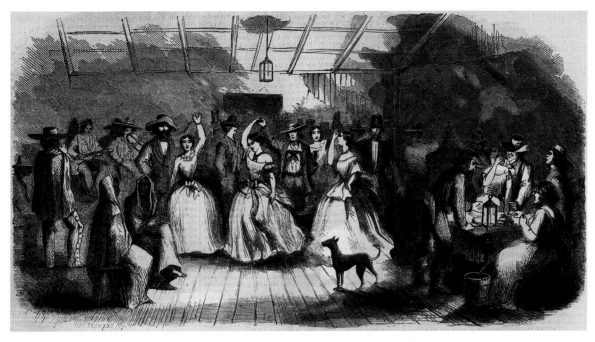

This San Antonio fandango scene appeared in
Frank Leslie's Illustrated Newspaper in 1859.

Fandangos drew a colorful crowd.

> At these fandangos may be seen the muleteer fresh from the coast or the Pass, with gay clothes and a dozen or so of silver dollars; the United States soldiers just from the barracks, abounding in oaths and tobacco; the herdsman, with his blanket and the long knife, which seems a portion of every Mexican; the disbanded ranger, rough, bearded and armed with his huge holster pistol and long bowie-knife, dancing, eating, drinking, swearing and carousing, like a party of Captain Kidd's men just in from a long voyage. Among the women may be seen all colors and ages from ten to forty: the Creole, the Poblano, the Mexican and rarely the American or German—generally, in such cases, the dissipated widow or discarded mistress of some soldier or follower of the army.[8]

One Sunday while passing the door of the church on Main Plaza, Everett noticed two men "kneeling near the door in a pious attitude, which would doubtless have appeared very sober and Christian-like had not each held a smart game-cock beneath his arm." Perhaps having asked for divine blessing on their fortunes in what was to follow, the pair rose and headed around to Military Plaza behind the church for one

of the cockfights held "every Sunday, just after mass." On occasion wooden walls were put up in the plaza and matadors brought from the Mexican border for bullfights.[9]

When U.S. troops left San Antonio in early 1861 as the Civil War approached, public safety suffered. "Vigilance groups" arose to fill the void. They could mete out their justice swiftly.

In September 1861, a thirty-five-year-old desperado named Bob Augustine, known for his violent drunken tempers, frequent shootings and general carousing, intimidated judge and jury into letting him go free. But as Augustine reached the Bat Cave's courtroom door, he froze in his tracks. Outside stood a vigilance committee of 300 men. He drew back to look out a window, but a vigilante lurking beside the window grabbed his hair and pulled him out. The men carried Augustine to a chinaberry tree in front of the Catholic bishop's home on the north side of the plaza and hanged him. That afternoon "Lanky" Pete—a suspect in a fatal stabbing—and four others were strung up from the same tree. Charles Herff, a teenager who skipped school to witness Augustine's hanging, was so shaken he could not sleep alone for four months. The bishop did the best he could to prevent more such incidents by cutting down all his trees.[10]

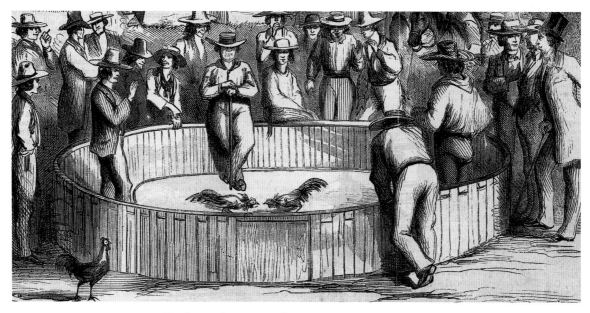

In the mid-nineteenth century, spectators
wagered on cockfights held in Military Plaza.

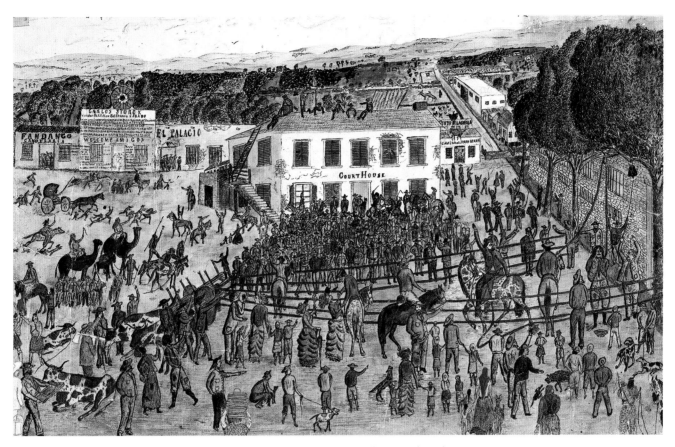

Desperado Bob Augustine was hung from a chinaberry tree in front of the Catholic bishop's house on Military Plaza in 1861. In his watercolor, eyewitness Charles Herff included, at the left, Indians plus camels like those in San Antonio during a pre-Civil War transport experiment and the sign "El Palacio," a probable bar in the building now known as the Spanish Governor's Palace.

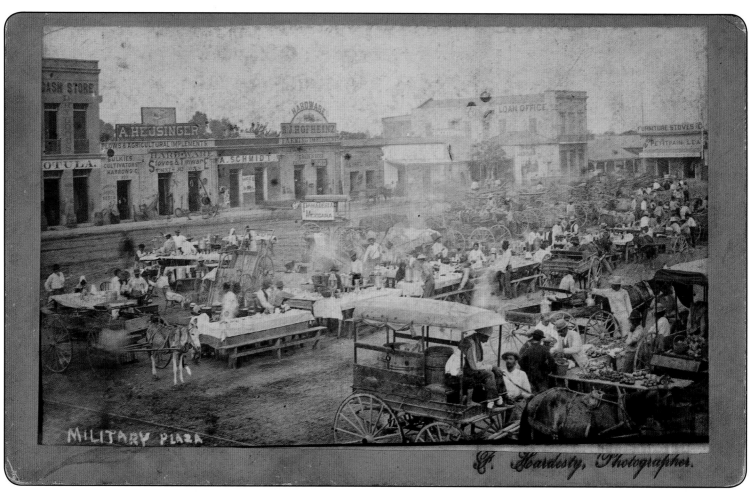

A vibrant open-air market filled San Antonio's Military Plaza in the 1870s and 1880s. In this view of the plaza's south side, smoke from fires cooking chili and other spicy foods rises behind food tables through a scene of wood sellers and vegetable vendors, mixed along lanes reserved for shoppers and wagons pulled by horses and donkeys.

2. Market Day

After the Civil War, Military Plaza's complexion shifted yet again. Cockfights moved west of San Pedro Creek, bullfights went away and in place of circuses came barking patent medicine purveyors with their wagons. Dr. J. L. Lighthall, the "Diamond King," offered cure-alls and painless dentistry, though most believed the gems he had for sale were, in reality, "paste." A phrenologist drew crowds on Saturdays.

As San Antonio and other towns on the frontier grew and ranchers prospered, by the early 1870s Military Plaza was transformed into a marketplace. Wagons of hay and carts of firewood wheeled in. Buyers crowded around tables of fruits and vegetables. Some sellers worked from blankets on the ground, while others, hawking candy, earthenware or birds, carried their wares around. At night the food sellers took over, serving seated rows of hungry diners.[1]

The official market house on Market Street off Main Plaza was carefully regulated, and its fees produced significant revenues for the city. Military Plaza's open-air market was seen as an unofficial convenience for residents. It remained free of a city oversight committee until 1888, though, outside the front door of city hall, it did get addressed by a few ordinances, most dealing with public safety and sanitation concerns.[2]

But an overall plan for vendors seems to have been followed, at least from time to time. Guidebook writer Stephen Gould described food vendors as organized in the center of the plaza "rain or shine." The lineup around the edges varied through the years, but when Gould wrote in 1882 the central western side was reserved for firewood, cotton, wool, hay, grain and produce wagons, all "placed in perfect order and lines, so as to preserve the adjacent street lines." Beside them sellers "squatted on the ground before small squares of wild fruits, and nuts in their season," all far enough from curbs so wagons and mule-drawn streetcars could pass. Larger-scale vegetable and fruit vendors lined the plaza's east side. North of the vegetable tables one could buy butter, eggs and poultry.[3]

Activity began before daybreak, as food vendors set up to serve breakfast. Fruit and vegetable growers unloaded their carts by the flare of kerosene lamps, and were known to quarrel loudly with others over a preferred location. Produce was arranged in pyramids and patterns to attract buyers. At dawn came their first customers, kitchen staffers of the better hotels and restaurants looking for the choicest produce. They paid the asking price for top quality, knowing they could not do better at the city's market house. Grocers looking for produce to resell also came early but sometimes purchased in such quantity that little was left for others, leading city council by the late 1870s to stipulate that resellers not purchase from "the country

dealers" before 8 a.m. Next to arrive were affluent residents' maids and cooks, who did not hesitate to bargain. Later came homeowners, usually husbands alone or with their wives, who hesitated to enter the market unescorted more from a sense of propriety than from any actual danger.[4]

Setting up after sunrise were dealers in nonperishables—hides, wood and hay for horses. Firewood sellers seemed to have a captive market. "All the available fuel within twenty or thirty miles has been exhausted," reported the *San Antonio Herald* in 1876. Without a railroad, coal could not easily be brought in to heat the city. Some peddlers gathered sticks and carried them around on donkeys, which could also pull a cartload. But a hauler with an ox and wagon could justify a trip of several days far out into the countryside, buying wood from landowners glad to be rid of it.[3]

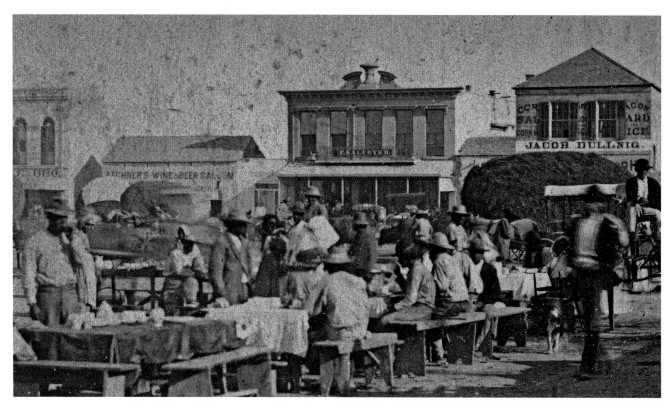

Breakfast tables are spread on the north side of Military Plaza across from Frederick Kalteyer's drugstore. The carved mortar and pestle in the broken pediment above its roofline was a landmark in the skyline.

In the blur of the slow-exposure photography of the day, the food preparer at left apparently has scooped a handful of masa dough from the container and is preparing a tortilla for diners at his table on the west side of Military Plaza in 1887.

During a morning lull on the plaza's south side, wagon drivers already aboard may be waiting for fellow drivers at the table to finish breakfast.

Individual hawkers wandered throughout. Some were selling earthenware, hanging from a rope over their shoulder. Candy vendors offered rolled pecan-filled sticks called *envueltos*, white or brown oblong cakes of cane sugar termed *piloncillo*, confections topped with pecans and named *pepitorias* and *melcocha*, taffy-like twisted sticks filled with pecans.

Tourists were especially taken with the bird sellers, who held cages of mockingbirds, Mexican canaries or cardinals caught near the sellers' homes in the western outskirts of town. The brushy neighborhoods provided reeds for the woven birdcages, held together by wooden pegs. "Mexican women monopolize the bird selling trade and are adept at it," observed Stephen Gould, and "are as a rule better traders than the men." He advised visitors that they could purchase the birds "quite cheaply, if they adopt the rule to offer half of the asking price of the peddlers."[6]

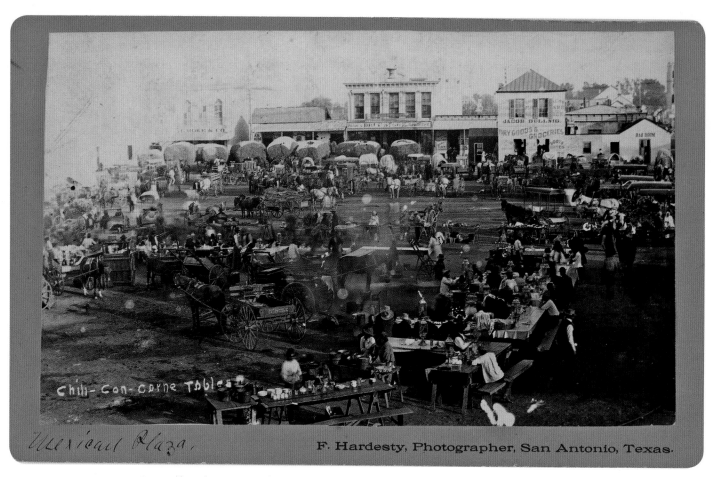

Chili-Con-Carne Tables

Mexican Plaza,

F. Hardesty, Photographer, San Antonio, Texas.

As market day gets under way, Military Plaza reflects a general order. Food vendors cluster in the center, wagons of vegetable vendors line the east side at right, hay wagons line the north side and at left are wagons of wood sellers.

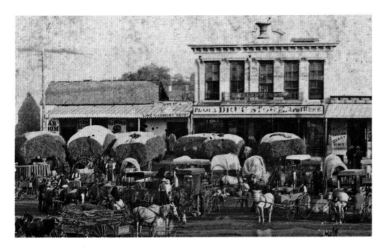

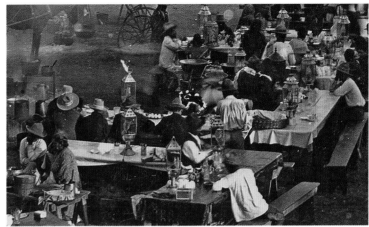

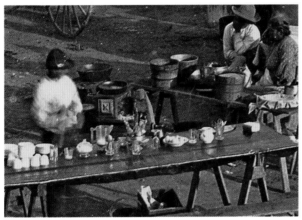

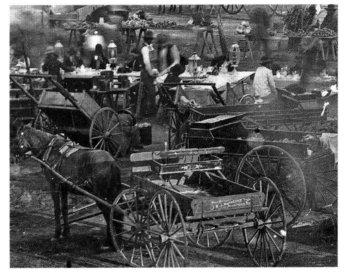

These details from the cabinet card on the facing page focus on the crowd on Military Plaza, showing hay dealers lined up with their wagons, chili vendors preparing meals while diners wait to be served or, at left, have a cup of coffee. Painted on the back of the buckboard above is the name of R.J. Hofheinz, the agricultural implements dealer on the south side of the plaza.

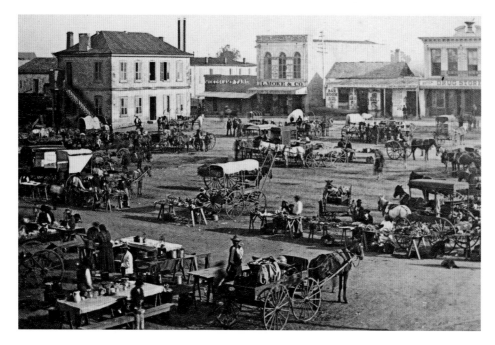

In this view to the northwest, the hay wagons are gone. Vegetable vendors line the side of the path beyond the food tables. San Antonio's city hall, with the jail behind it, is at the far left. Across the street, next to Leon Moke's drygoods store is Moke's Camp Yard, for the convenience of wagon drivers spending the night.

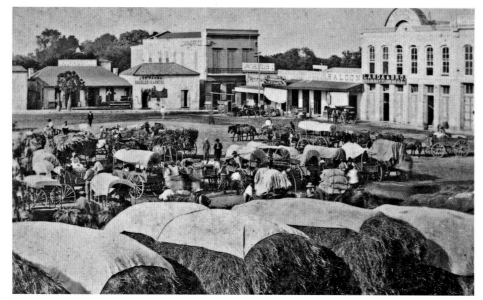

Haywagons help frame this view of the southwest corner of Military Plaza. On the far side of Dolorosa Street, to the left of Alexander Varga's saddle and harness shop, is the onetime home of Texas Declaration of Independence signer José Francisco Ruiz, rescued in 1943 and moved to its present location behind the Witte Museum.

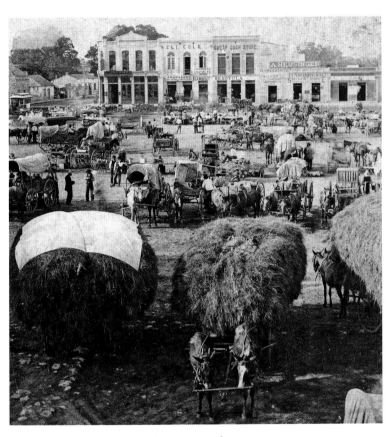

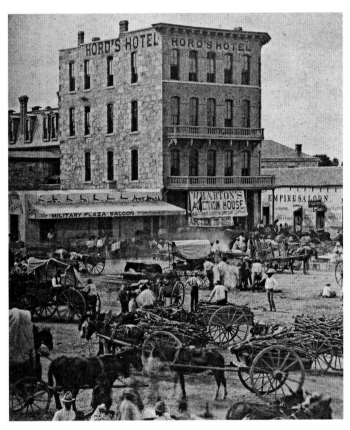

A mule-drawn streetcar makes a cameo appearance at the upper left in this view of the plaza's southeast corner, at Dolorosa and South Flores streets, anchored by Leonardo Orynski's corner drugstore and, upstairs, offices for five physicians.

Two saloons flank Hord's Hotel—later the Southern Hotel—near the southeast corner of Military Plaza. Despite the street noise, the hotel was a favorite of visiting cattlemen and ranchers.

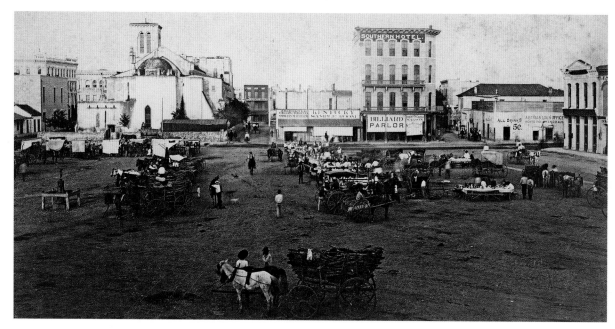

This late 1880s view of the east side of Military Plaza shows its proximity to Main Plaza, which opens along the fronts of San Fernando Cathedral and buildings facing the far side of the block.

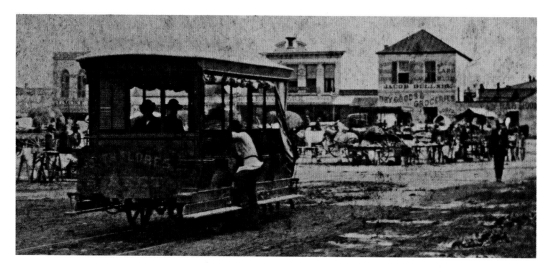

A passenger boards the South Flores Street car of San Antonio's mule-drawn street railway near the plaza's northeast corner in about 1880.

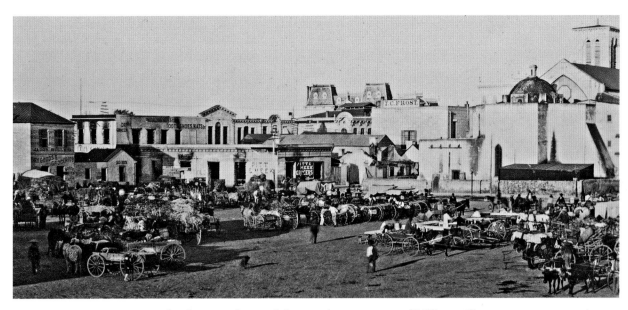

Rising in the distance beyond the northeast corner of Military Plaza are the twin towers of the Bexar County Courthouse on Soledad Street.

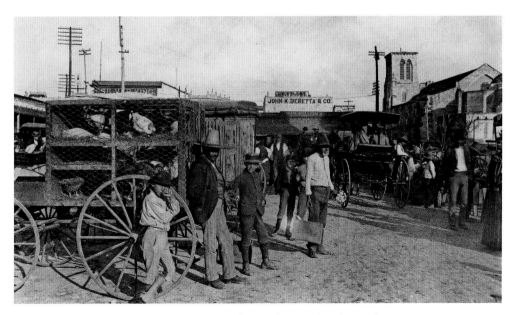

Poultry vendors were assigned to Military Plaza's northeast corner.

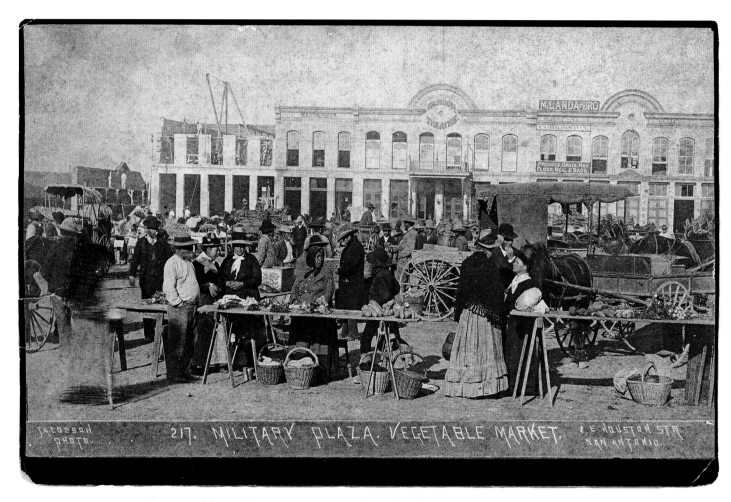

The vegetable market was once assigned to the plaza's east side, but moved around. This view shows it on the west side of the plaza, where a well-dressed couple, right of center, seems to be discussing a purchase. Wives rarely visited the plaza market alone, more from a sense of propriety than from any danger.

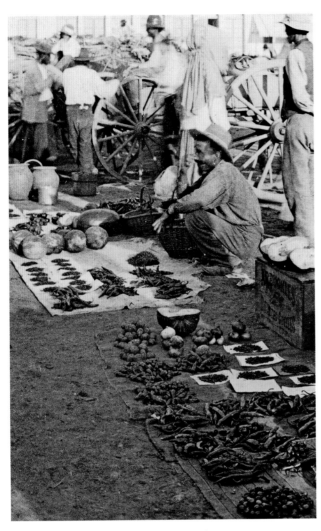

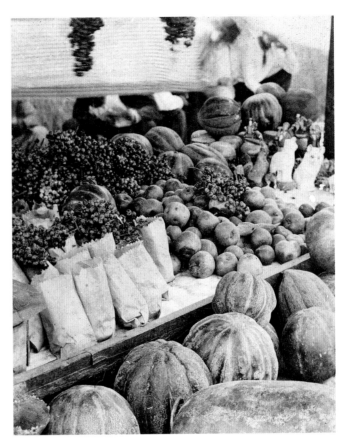

Photographer Frank Hardesty took this close-up of a fruit stand.

In a view labeled "Military Plaza at 6 a.m.," a vegetable vendor has spread out his produce on a blanket on the ground.

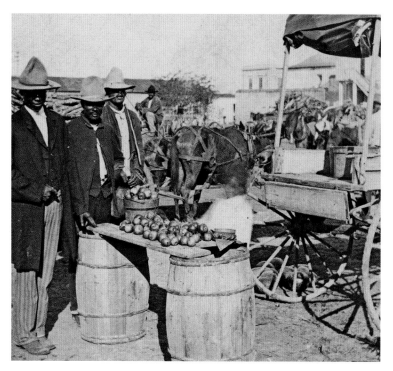 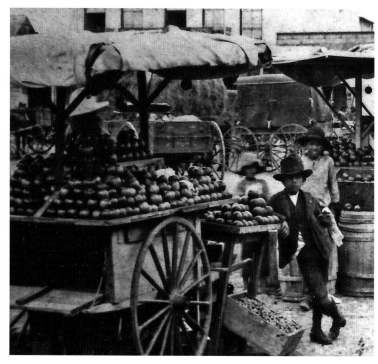

Produce displays varied widely, from the one at left on boards over two barrels—with more on the ground behind the wagon wheel—to the sort of artistic stacking on the cart at right that some dealers found increased sales.

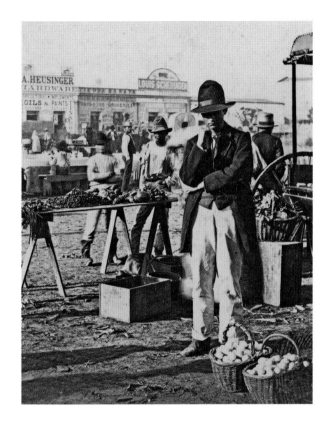

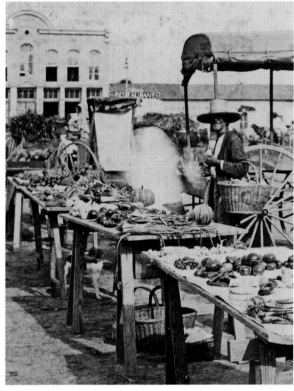

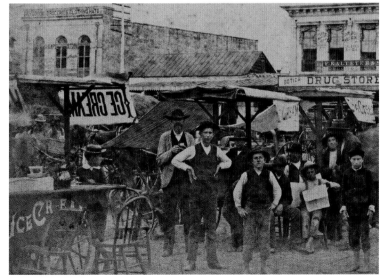

above left This vendor's stock included baskets of potatoes.

above right Basket in arm, a shopper appears to await being handed a purchase by a vendor blurred by motion.

left
In the mid-1880s sale of ice cream was made possible by the no fewer than three ice manufacturers in San Antonio.

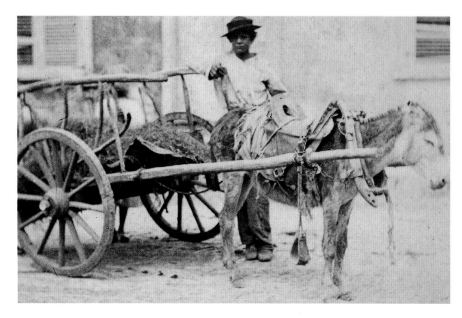

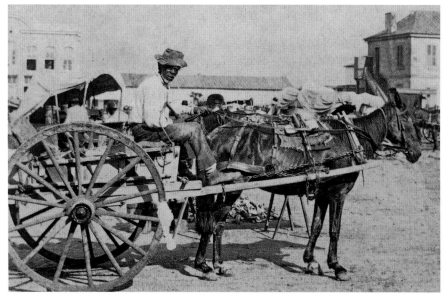

Hay or firewood could be
delivered by a boy with a burro-
drawn cart, an older person—
identified as "Plaza Dude"—
or by a boy simply riding his
own burro.

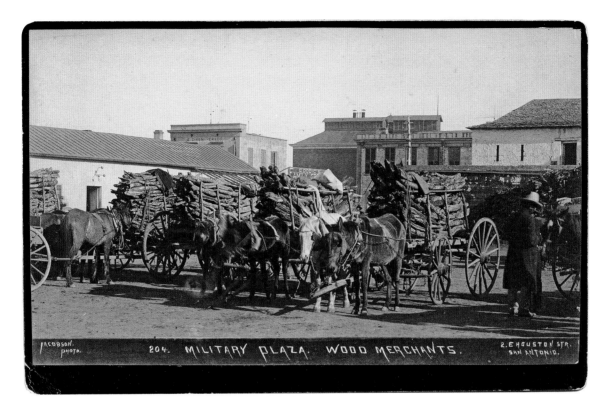

204. MILITARY PLAZA. WOOD MERCHANTS.

JACOBSON. PHOTO.

2. E HOUSTON STR. SAN ANTONIO.

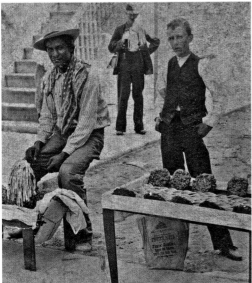

Wood merchants on the west side of the plaza have hauled in firewood from the distant countryside.

left A street vendor armed with a brush to whisk away flies appears to be selling pepitorias, a treat topped with pecans.

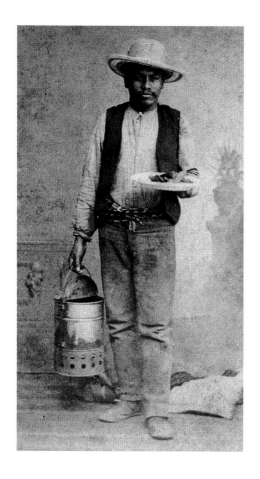

Visitors were so charmed by San Antonio's street vendors that photographers brought the vendors into their studios for formal portaits to be sold to tourists. Shown here, from upper left, are sellers of tamales, pepitorias, earthenware and, at left, melcocha, taffy-like twists filled with pecans.

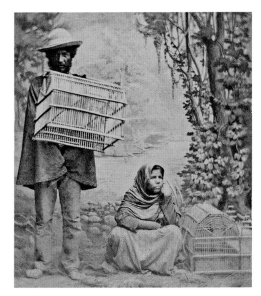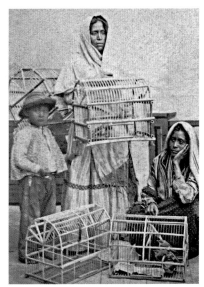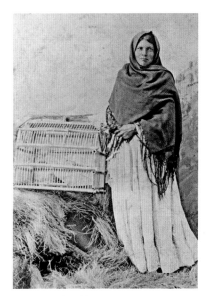

Studio settings add a romantic sense to these portraits of San Antonio bird sellers.

Catching birds and constructing birdcages was a family affair
in brushy neighborhoods on the western edge of San Antonio.

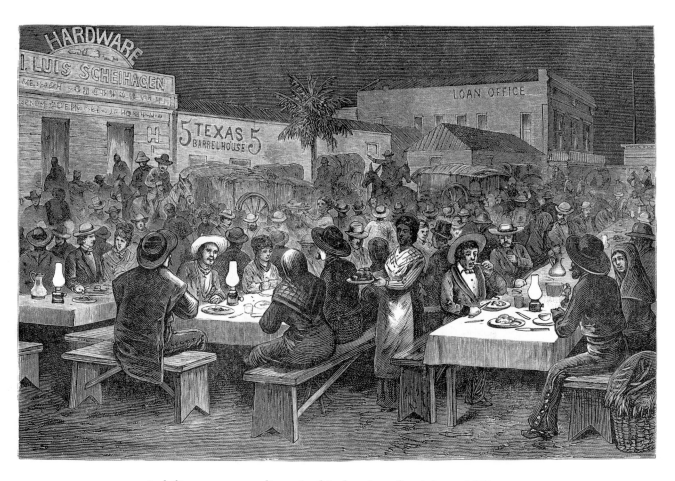

A chili queen serves diners in this drawing of a night on Military Plaza. It appeared with an article on San Antonio in the German periodical *Um die Welt* in 1882, when interest in German emigrants to Texas was high. Observers of this scene at the time lamented that photographs could only be taken in the daytime, and could not capture such memorable nighttime views.

3. The Chili Queens Reign

By mid-morning the first wave of shoppers had left Military Plaza. Sellers played cards in the shade of wagons or took a siesta in the early afternoon heat until the tempo picked up again after 3 p.m., when customers began returning to make purchases for the evening meal. At dusk vendors reloaded their unsold stock into their wagons and drove off, leaving the chili queens to reign over the night.[1]

In the daytime food vendors clustered in the middle of the plaza, laying planks across sawhorses and covering the boards with oilcloth. They put out stacks of plates to receive servings of breakfast or lunch cooking and warming on the small fires or braziers below. Glasses or cups awaited coffee, hot chocolate or atole, a corn-base drink spiced with cinnamon and vanilla. Urns stood ready to dispense the drinks. Other plates and small bowls held breads and condiments like oregano or chopped onions. Cruets of seasonings waited to be dashed on the already spicy foods.[2]

At night rows of tables were set up where vendors had been along the plaza's edges. Burros carried in food nearby families had prepared at home, using recipes brought up from northern Mexico. It was warmed over flickering fires that helped glassed tin lanterns illuminate the diners seated on benches. The

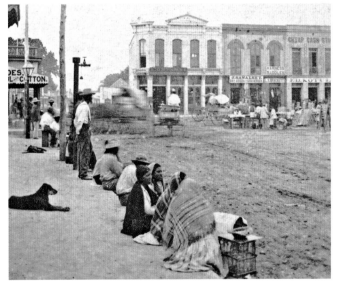

food was tended by the parents and served by the prettiest daughter, though some older women and men managed their own stands. A large bowl of chili with tortillas and coffee cost ten cents, today's equivalent of about $2.[3]

The term "chili" queen compresses the variety of offerings, which ranged beyond chili con carne to frijoles, tamales, enchiladas, chiles rellenos, menudo, goat meat, tongue and fried eggs topped with chili sauce. Some found the spicy foods delectable, others deemed them passable, while at least one diner thought they "tasted exactly like pounded fire-brick from Hades."[4]

"The chili queen would take an order with a lurking coquettish smile which she couldn't help," recalled one observer. They were "putting them-

Business is slow for bird sellers and others, who wait on the curb along the east side of Military Plaza for San Antonians to awaken from the afternoon siesta.

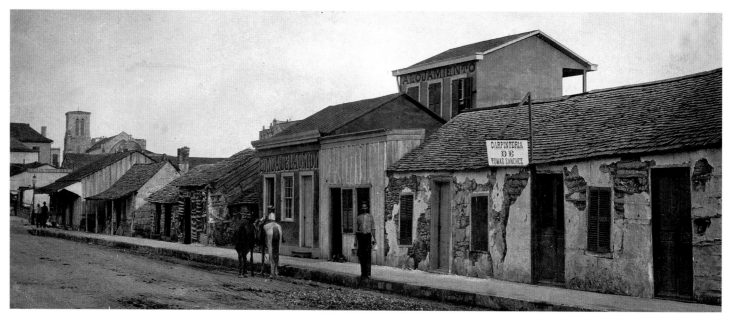

Frederick Law Olmsted's phrase "odd and antiquated foreignness" could describe this West Commerce Street streetscape just beyond San Pedro Creek, a neighborhood perhaps where residents prepared food for evening meals on Military Plaza. One food preparation site could have been the Fonda de la Union, left of center, the sort of small restaurant sometimes operated by chili queens. The *alojamiento* behind it offered lodging.

selves out to be agreeable to all, but they could hold their own easily in sharp badinage with the kidders. . . She understood the art of coquetting with a dude" to get his business, "but avowals of passion she warily passed up as so much kidding."[5]

Young or old, attractive or less so, "all the queens smoked bewitchingly and with a grace entirely theirs. They preferred to roll their own with corn shucks and black tobacco, and they were adept at the art. It was a mark of favor for the queen to roll one for a customer or a friend while she rolled one for herself. When a tip was handed over it was received with a curtsy, or bobble, half in light fun as well as gratitude."[6]

A few chili queens played the guitar; others sang or danced to the sound of a fiddle. There were reports of the scene being boisterous and disorderly and counterclaims that people were loud and laughing "only because of the good time they were having." In any event, class distinctions were lacking. "A Mexican boot-black and a silk hatted tourist would line up and eat side by side. Cowboys, merchants and hack drivers touched elbows. . . . All were free and equal at the chili stands."[7]

French-born artist Theodore Gentilz, who lived three blocks north of Military Plaza, was so intrigued by the chili stands that in the 1850s he prepared this study, entitled *Almuerzo en la Plaza de Armas* or "Lunch in Military Plaza."

41

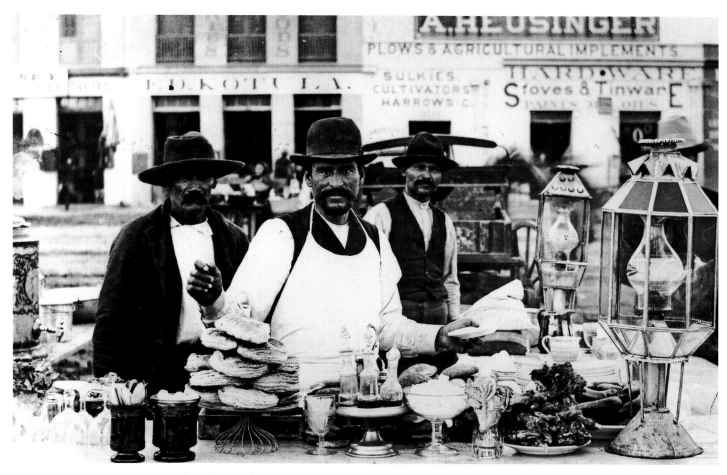

This classic photo of a chili vendor shows the variety of condiments and seasonings available on plates and in cruets. When mealtimes ended, disassembled stands were packed in wagons parked behind and driven home to wait for the next day.

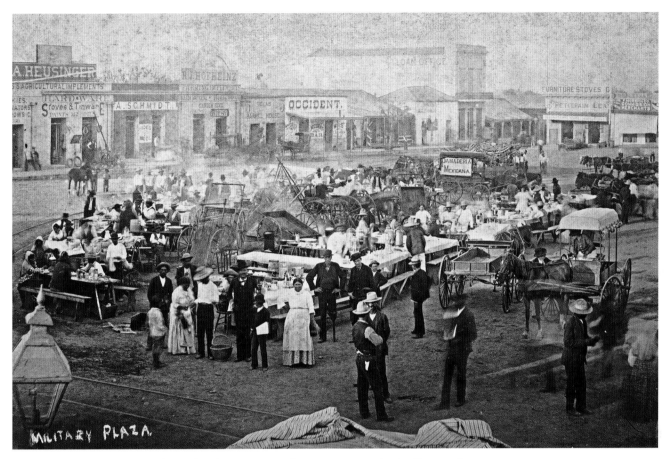

MILITARY PLAZA

Judging by their aprons, the two women in the lineup closest to the camera at front left center are chili queens. The unusual posed group stands by the street railway tracks at the southeast corner of Military Plaza and includes, near the front center, a man with a wooden leg. The photographer, Frank Hardesty, who advertised "special views made anywhere," may have been commissioned by the well-dressed man, perhaps a tourist standing by his young son, to photograph them in the exotic setting.

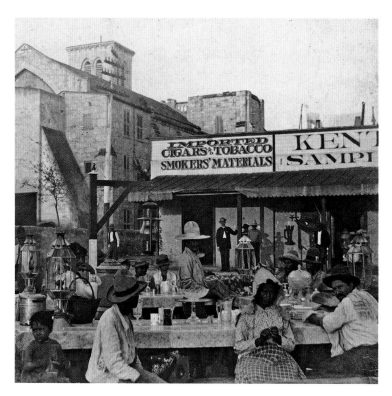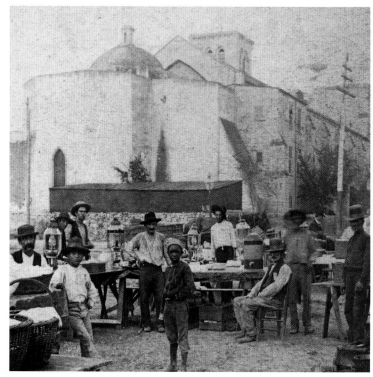

These diners gathered around various chili stands in the shadow of San Fernando Cathedral in the mid 1880s. The one at the left appears to have been run in the traditional manner, with the man in the family running the stand while his attractive wife or daughter—perhaps the girl beside the lantern—waited on customers.

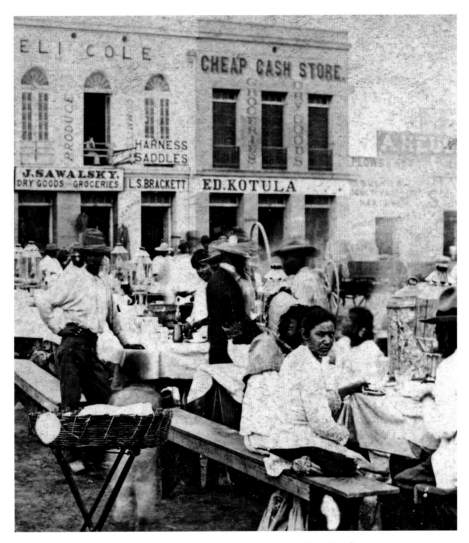

Early evening diners on the south side of
the plaza turned to the photographer.

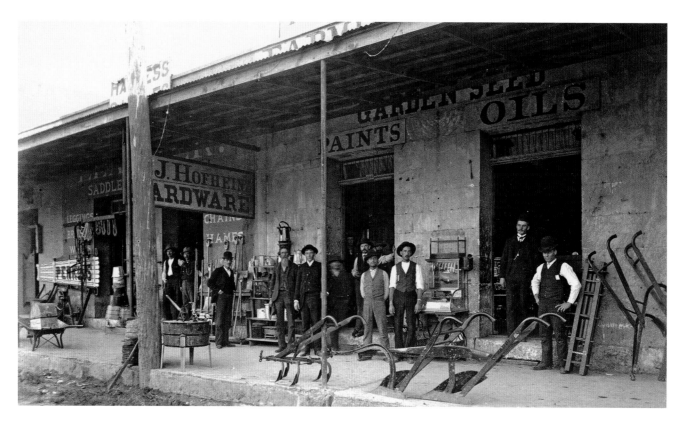

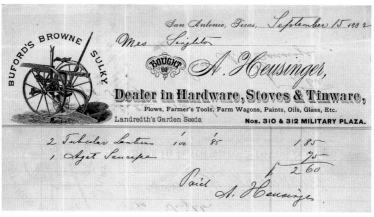

On the west side of Military Plaza, Rudolph J. Hofheinz and Adolph Heusinger had adjoining businesses serving the plaza's longtime farm and ranch market.

4. Around the Plaza

By the mid 1870s increased use of Military Plaza was exacting a price. There were complaints. Bad odors came from neglected refuse, tethered animals attracted too many flies and the eastern part of the plaza was several inches higher than the western part, which heavy rains turned "into a reservoir and mud-hole." The *Express* thought the plaza "as ugly and offensive as a hog pen in this rainy weather." In 1876 the city bore down on some owners claiming land encroaching into the plaza east of the Bat Cave, and razed their buildings. Frederick Kalteyer, a druggist on the plaza since 1854, was the lone neighbor to contribute to the project and gained better exposure to the plaza in front of his new store, built in 1877. The rubble was spread over the western part of the plaza in an attempt at leveling, but that section got just as muddy as it had before.[1]

Military Plaza was always more respectable and safer than the seamy neighborhood just west beyond San Pedro Creek, but some behavior did spill across. Drunks were common after 6 p.m. as were fights, but they usually drew little attention from passersby. The "regular fight occurred last night on Military Plaza," the *Express* reported in October 1879. "The parties wanted to carve each other with knives, but didn't." Robberies of stores were not uncommon, and there was an occasional escape from the Bat Cave jail. One prisoner made it over the broken glass that topped the jail enclosure only to be nabbed by police "attracted by the clanking of his chains as he made his way across the plaza." The city council suggested building a wooden cage inside the jail to prevent such breakouts. The council tried passing ordinances to curb shootings, at first with little effect. "Military Plaza was the scene of two altercations involving the use of 'Colts,' not of the equestrian variety, last evening," the *Daily Light* reported in December 1880. "The police were not on the scene, as usual."[2]

Most such trouble originated in the small bars or "barrel houses" first opened

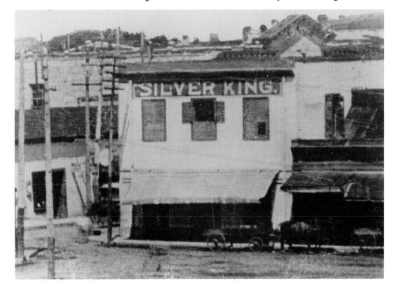

Despite a modest exterior, the Silver King Saloon at the northeast corner had become Military Plaza's leading watering hole.

on the plaza in the 1850s. Patrons of the larger saloons opening in the 1870s were better behaved, though gunfire indoors was still not uncommon. Military Plaza's leading saloon—near its northeast corner—was the Silver King, with a silk-covered ceiling, mirrored walls, plush rooms for gaming tables and an art gallery with copies of old masters and paintings of women in various stages of undress. The Silver King was a favorite destination of visiting ranchers and high-stakes gamblers, and no stranger to shoot-outs. When torn down for the widening of Commerce Street in 1915, its proprietor, J. C. Roberson, who had begun there as a bartender in the 1880s, could point out bullet holes in the floor and in the transom. "Sometimes the smoke has been so thick I could not see through it," he told a reporter, "but somehow I have come out without a scratch."[3]

Variety theaters featured dramas to draw patrons to their bar and gaming rooms, though the smallest theaters were ridiculed as little more than brothels. Some sent brass bands into the plaza to promote business. On its northwest corner Military Plaza had the Green Front Variety Theater, "patronized largely by frontiersmen and soldiers." The Green Front is noted for the death in 1878 of a beautiful actress named Georgia Drake, shot by a jealous boyfriend who rushed in and scattered the audience. It closed about the time of the debut six years later on the plaza's west side of San Antonio's finest and most reputable vaudeville hall, the Fashion Theatre. The Fashion had its own orchestra, advertised itself as "open every night of the year"—thus becoming "The Only Continuous Pleasure Resort in San Antonio"—and promised to have "the strictest order always maintained."[4]

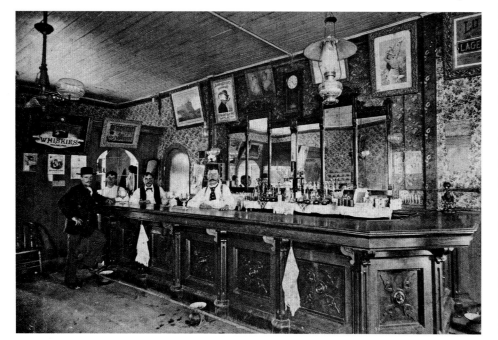

Despite the attention drawn to Military Plaza's colorful market and entertainment venues, it was still a regional center for agricultural trade, a legacy

Bartenders were ready to serve at this saloon, identified only as being on Flores Street, near Military Plaza.

48

of the plaza's earlier decades as a gathering place for wagons and goods bound for the outlying frontier. A favorite for visiting cattlemen was Hord's Hotel at the southeast corner, Military Plaza's only major hostelry, which extended the length of its block to Main Plaza. In addition to Frederick Kalteyer's drugstore on the north side was Leonardo Orynski's at the southeast corner. Each pharmacy had offices upstairs for five physicians.

By the mid 1880s there may have been as many saloons and theaters facing Military Plaza as there were groceries and dry goods stores. But their combined number—nearly twenty—was no larger than that of dealers in hides, wool, cotton, farm implements and the hay, grain and feed for the horses and mules that kept the city moving.[5]

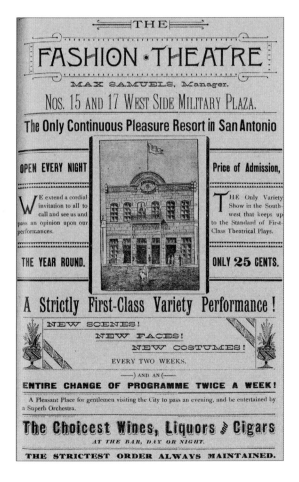

left "The strictest order always maintained," the Fashion Theatre assured its patrons.

When this photo was taken, Amaziah M. Beekman had become the agent for Issy Landa's wholesale grocery on Dolorosa Street, at Military Plaza's southwest corner. His sign covered part of the diagonal lettering advertising Produce, Grain, Hay, Flour and Bags.

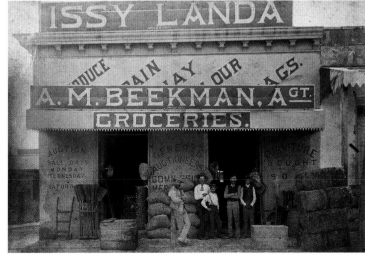

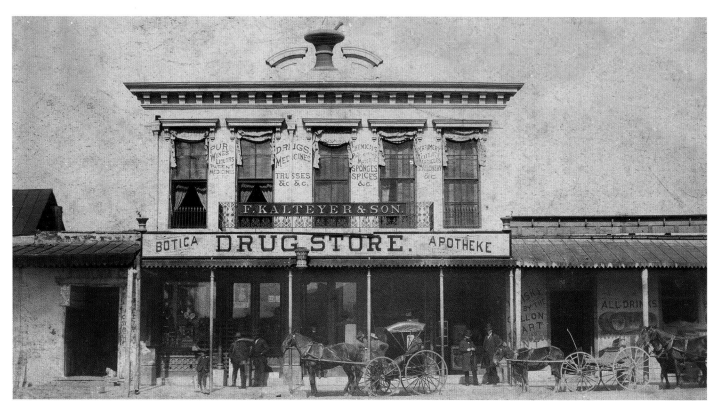

Frederick Kalteyer opened his first drugstore on
Military Plaza in 1854, and replaced it in 1877 with
this stylish landmark on the plaza's north side.

F. Kalteyer & Son offered a wide variety
of drugs and medical supplies.

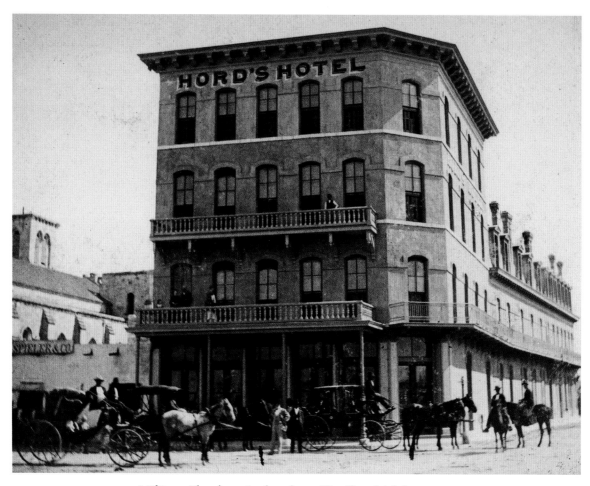

Military Plaza's major hotel was Hord's, which became
the Southern Hotel in the mid-1880s. It extended
the depth of the block on Dolorosa Street to another
entrance on the far end, fronting Main Plaza.

The vista from Hord's Hotel in the mid 1880s offered a timeline of San Antonio's growth. At lower right is the apse (1755) of San Fernando Cathedral. As North Flores Streets extends from lower left upward is First Presbyterian Church (1866). Two 1882 landmarks pierce the horizon beyond. At right is the spire of Madison Square Presbyterian Church and, left of center, the cupola of San Antonio High School—later Fox Tech—on Acequia Street, later renamed Main Avenue. Beyond, developers were beginning work on the Laurel Heights and Monte Vista neighborhoods.

‧ II ‧
MAIN PLAZA

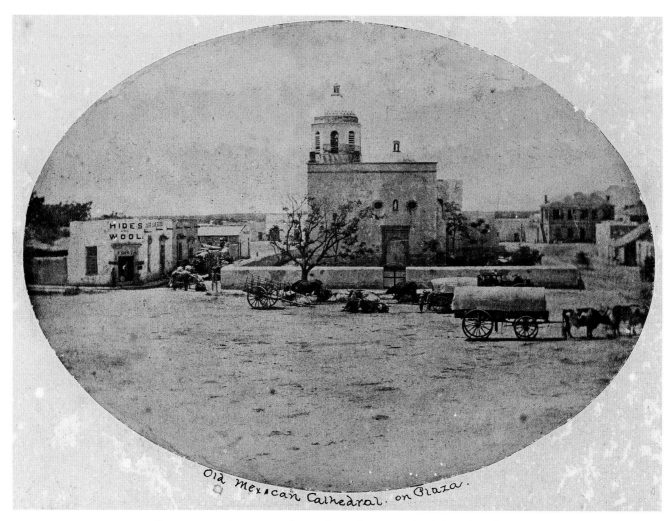

Old Mexican Cathedral on Plaza.

Oxen rest in the sun in this earliest photograph of the Church
of San Fernando, taken in about 1861. In the right background,
on Military Plaza, is the city hall and courthouse.

5. A Plaza for the Villa

Builders could not give Main Plaza's landmark San Fernando church the elegance of the five Roman Catholic mission churches and chapels then under various stages of construction around San Antonio. The missions had the resources of Spanish architects based at sponsoring missionary colleges deeper in Mexico, at Zacatecas and Querétaro. San Fernando was under the domain of the non-missionary bishop in Guadalajara, and San Fernando's priest had to work with the resources at hand.

Seventeen years passed between the laying of San Fernando's cornerstone in May 1738 and dedication of the finished church on December 12, 1755. In the meantime, builders did the best they could while civilians attended mass in other places, in the small room of what passed for a chapel at the nearby presidio or across the river at Mission San Antonio de Valero. The project was plagued by a lack of workers and funds, and by administrative and financial tangles. When a building was done in 1749, construction flaws caused it to be torn down and rebuilt on the old foundations. The completed church may have appeared crudely built compared with the classic mission churches of San José and Concepción, but it would serve the community well for more than a century. Its front entrance was designated the geographic center of San Antonio.[1]

Building the church was a priority for the fifty-six settlers recruited from the Canary Islands when they arrived in 1731 to form the Villa of San Fernando de Béxar. The site was at the head of their main square—Plaza de las Islas/Plaza Mayor, or Main Plaza—originally planned farther west but resited to a better-watered area. Past the plaza on the east was the San Antonio River. Along the west ran an acequia, or irrigation ditch. A stone's throw across the acequia was Military Plaza, center of the presidio garrison. The church faced east on Main Plaza. Its apse backed on Military Plaza.

Far easier to build than the church was the center for civilian government, the simple one-story Casas Reales built on the opposite side of the plaza. It stood amid the low stone buildings that lined the plaza and

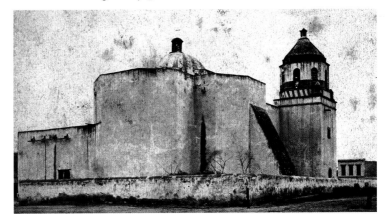

The Church of San Fernando as seen from the southeast on Military Plaza in about 1867.

57

spread along an irregular grid of connecting streets. Casas Reales became the town's administrative center as its formal designation Villa of San Fernando de Béxar faded away. Land once administered by the adjoining presidio had merged with the town's by the late 1770s. The separate village that once oversaw Mission San Antonio de Valero's land was fully incorporated with San Antonio in 1809.[2]

For the next hundred years, celebrations of feast days of various saints and other religious events broke the daily routine for Main Plaza and surrounding neighborhoods. A procession in 1840 honoring Our Lady of Guadalupe, patron saint of Mexico and of San Fernando, was described by Mary A. Maverick, who lived at Main Plaza's northeast corner:

> Twelve young girls, dressed in spotless white, bore a platform on which stood a figure representing the saint, very richly and gorgeously dressed. First came the priests in procession, then the twelve girls bearing the platform and carrying each in her free hand a lighted wax candle. Then came the fiddlers, behind them playing on their violins, and following the fiddlers the devout population, generally firing off guns and pistols and showing their devotion in various ways. They proceeded through the squares and some of the principal streets. Every now and then they all knelt and repeated a short prayer, an Ave Maria or Pater Noster. Finally the procession stopped at the [Church] of San Fernando, on the Main Plaza, where a long ceremony was had. Afterwards, the more prominent families, taking the patroness along with them, adjourned to Mr. José Flores's house, on the west side of Military Plaza, where they danced most of the night.[3]

Other religious celebrations featured bullfights, within barriers put up on Main and Military plazas. Saints' days were marked with El gallo corriendo, or the "Running Rooster," an exercise in riding skills. A rider on a fast horse carried a rooster, "generally some noted fighting bird," and was chased along a designated route by others on horseback seeking to grab the rooster. The winner was the rider passing the goal with the bird, which he got to keep. The bird, however, did not always survive—nor did all the riders, who were often unseated and sometimes died from the fall. A watermelon could be substituted as the prize.[4]

Significance of the event perplexed some newcomers. After a corriendo celebrating St. John the Baptist on June 24, 1860, one recent arrival, Lt. Col. Robert E. Lee, acting commander of the U.S Army's Department of Texas and a sometime boarder on Main Plaza, wrote home to Virginia that the temperature was "100 degrees in the shade, a scorching sun and the dust several inches thick. You can imagine the state of the atmosphere, the sufferings of the horses, if not the pleasure of the riders. . . I did not know before that St. John placed so high a value upon equitation."[5]

In addition to hosting religious observances, Main Plaza was a setting for events of broad military and political significance.

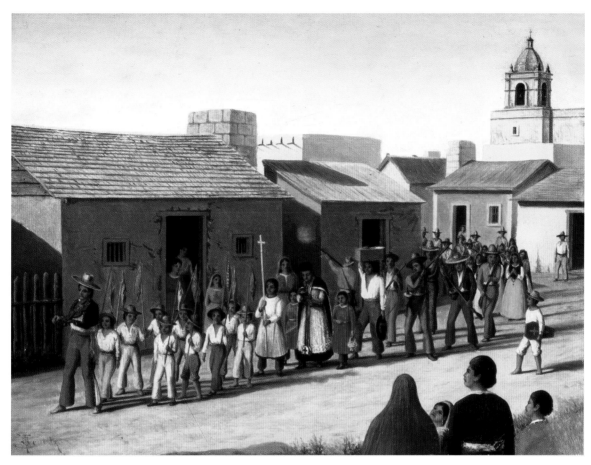

Religious processions from San Fernando included this one in
the 1840s for the funeral of a child, titled *Entierro de un angel*
by painter Theodore Gentilz, who lived a few blocks away.

In 1749, after Apache attacks plagued outlying areas, Toribio Urrutia, captain of the presidio, led a raid that took dozens of Apaches prisoner. He offered to return the prisoners in exchange for a peace agreement, and the Apaches agreed to negotiate. A large group of Apaches came to a hall built for negotiations on Main Plaza. There they enjoyed a feast of beef, corn, squash and fruit, and attended mass in the church. A peace was ratified and the prisoners were returned.

Early on the morning of April 19, San Antonians and Apaches gathered to celebrate. A large hole was dug in the center of the plaza to bury instruments of war—a hatchet, a lance, six arrows and a live horse.

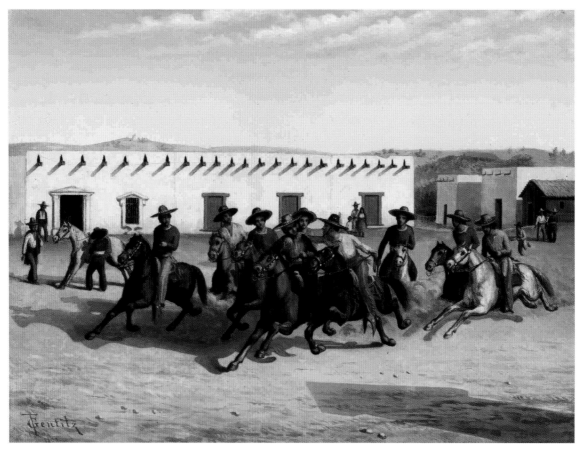

Theodore Gentilz used artistic license to add some hills to the 1840s setting
of Main Plaza, where horsemen are shown racing in *Corrida de la sandía*,
or race of the watermelon, in which riders tried to snatch a watermelon or,
at other times, a rooster from the grip of the lead rider.

Captain Urrutia and four chiefs joined hands and danced three times around the hole. The Indians followed along with priests and civilians, then drew back. At a signal all rushed to the hole and quickly buried the weapons and the live horse. "This over, the Indians gave great whoops and the Spaniards cried three times, '*Viva el Rey*' ('Long live the King!')."[6]

Nearly a century later, in 1835, a fortified Main Plaza was a combat scene as Texans drove out an occupying Mexican army and ended the Siege of Bexar. When the Mexican army returned the next year,

the flag of the Mexican president and military commander, Santa Anna, flew from San Fernando's tower, where a Mexican Army bugler sounded no quarter for defenders of the Alamo.

More conflict would come. In 1840, Comanche chieftains were in the Casas Reales negotiating the return of white hostages when Texans, misinterpreting how the Comanches were interacting, suddenly announced that they were hostages.

"The Comanches instantly, with one accord, raised a terrific war whoop, drew their arrows and commenced firing with deadly effect, at the same time making efforts to break out of the hall," recalled plaza resident Mary A. Maverick, an eyewitness to what followed. The county judge, sheriff and five other Texans in the council house were killed. When the Council House Fight ended, thirty-three Comanches were dead and the remaining thirty-two were prisoners. The incident hardened Comanche hostility to whites in Texas, contributing to much of the later violence on the frontier.[7]

One Sunday morning two years later—on September 11, 1842—a Mexican army of 1,200 led by Gen. Adrián Woll appeared. Mexico still did not recognize Texas independence—declared six years before— and had occupied San Antonio six months earlier. This time court happened to be in session at the Casas Reales, where lawyer and former mayor Samuel A. Maverick was trying a case before Judge Anderson Hutchinson. Both were captured along with fifty-one others, and marched as prisoners across the Rio Grande and on to Perote Prison near Vera Cruz. Merchant John Twohig blew up his store at the northeast corner of Main Plaza to keep its ammunition from falling into Woll's hands.

Annexation of Texas to the United States in 1845 sparked the Mexican War. In October 1846 U.S. Army regulars and volunteers camped in San Antonio made a ceremonial departure from Main Plaza into Mexico, where they helped win the Battle of Buena Vista. One participant, Pvt. Sam Chamberlain, who portrayed the scene in a watercolor, wrote: "The command made quite an imposing appearance as they marched through the Grand Plaza of San Antonio, which was crowded with a motley assembly of wild looking Texans, Mexicans in their everlasting blankets, Negro Slaves, with a sprinkling of Lipan Indians, in full dress of paint and feathers, White women, Squaws and Senoretas [sic]."[8]

Once the war ended in 1848, activity in town picked up. Freight wagons crossing the frontier paused on the plazas, and stagecoaches stopped at Main Plaza's new three-story Plaza House, considered San Antonio's first genuine hotel.

For several decades, the Plaza House balcony held orators addressing crowds and those observing civic and military parades below. Texas Governor Sam Houston drew cheers from a crowd as he opposed secession in a speech from the second-floor balcony in 1860. On February 1, 1861, however, a secession

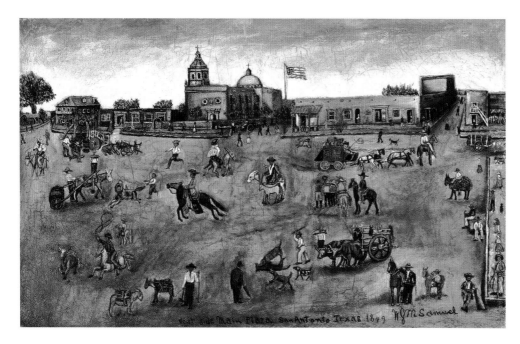

Indian fighter and soldier William G. M. Samuel settled in San Antonio at the end of the Mexican War and, without formal training, painted a rare documentation of Main Plaza. His view of the west side, dominated by the 1755 church of San Fernando, includes a stagecoach and water and wood vendors.

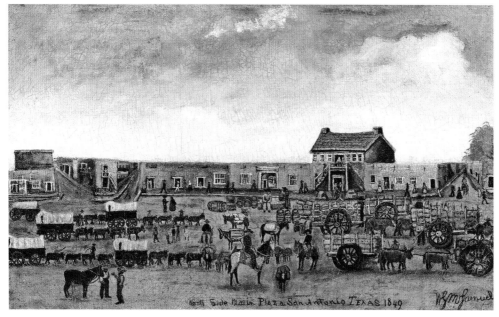

The Plaza House, San Antonio's first genuine hotel, rises above the stone and adobe buildings lining the north side of Main Plaza in 1849. Mule teams and oxen are shown with the freighters that hauled goods from the Texas coast and on to the farther frontier.

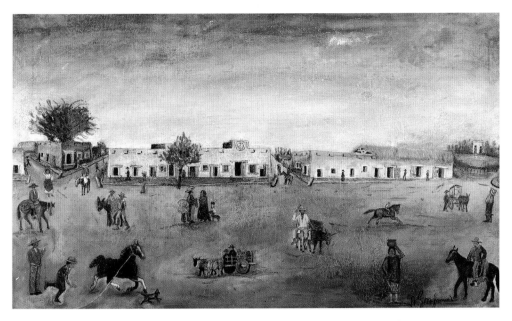

Left of center, a clock appears atop the council house, built as Casas Reales, the first courthouse in Texas. In the plaza's northeast corner at far left, a cypress tree shades the home of Texas Declaration of Independence signer Samuel A. Maverick.

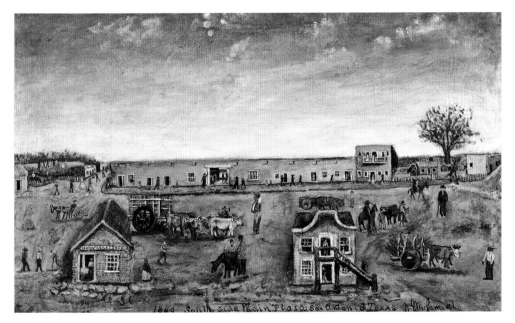

Ending the long mercantile block in the distance along the south side of Main Plaza is a two-story hostelry that evolved into the Central Hotel and then the St. Leonard Hotel. In the foreground are two stores that encroached on the open plaza by facing the south side of Commerce Street, which crossed the plaza along the north. The one at the right was owned by onetime mayor Bryan Callaghan, father and grandfather of future mayors.

convention in Austin approved withdrawal of Texas from the Union. Fifteen days later, the commander of the U.S. Army's San Antonio-based Department of Texas—Maj. Gen. David E. Twiggs—was pressured into surrendering all federal property in Texas to Confederate commissioners and ordering evacuation of the 2,700 Union troops stationed in the state. A formal transfer ceremony was held on Main Plaza, with troops passing in review at the Plaza House.

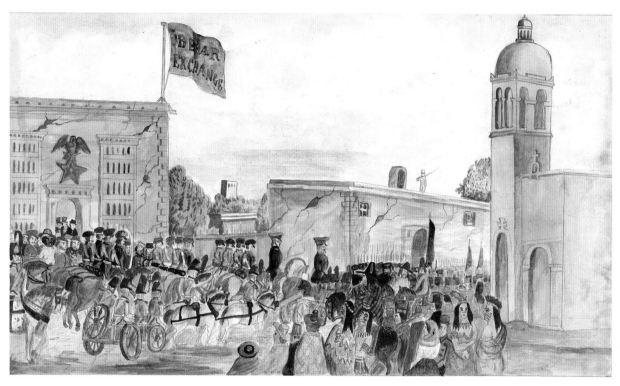

Prolific Mexican War artist Sam Chamberlain, who served as a private, included in his portfolio a fanciful watercolor of troops departing San Antonio for the front in 1846. As other artists have, he improved on the actual appearance of San Fernando's original bell tower. He also greatly exaggerated the size of the Bexar Exchange, a saloon in which he had many adventures.

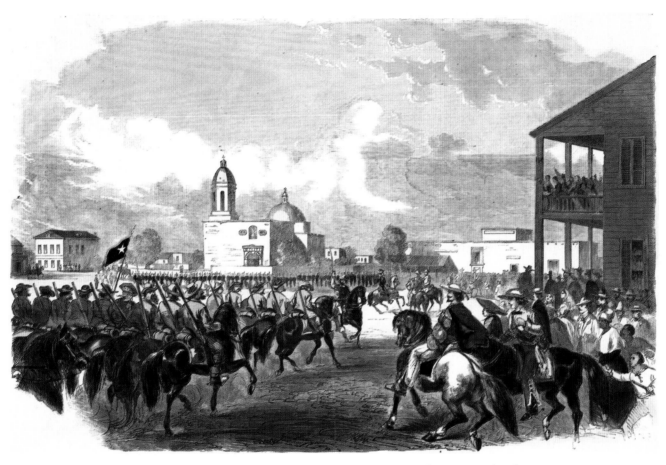

The Plaza House, far right, served as a focal point for Texas officials who formally received the U.S. Army's surrender of federal property in the state on Main Plaza in February 1861, as the Civil War drew near. This view, with the customary redrawing of San Fernando's steeple, appeared in the New York periodical *Harper's Weekly*.

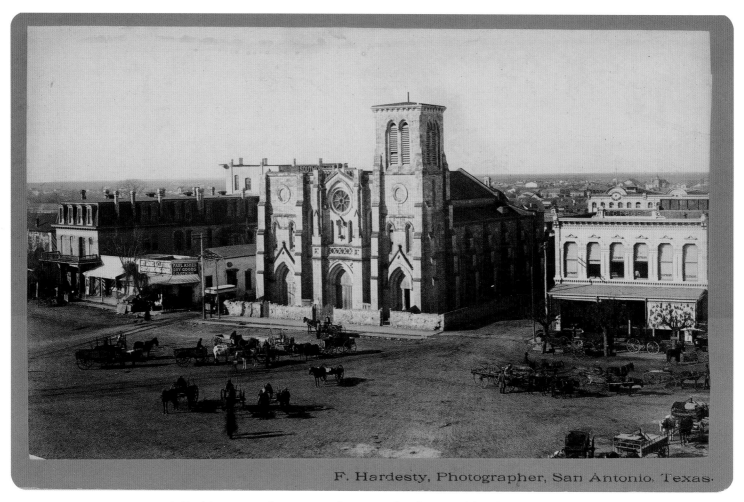

F. Hardesty, Photographer, San Antonio, Texas.

A Gothic nave and one tower for Main Plaza's venerable Church of San Fernando were completed in 1873, signaling a new era for church, plaza and city. San Fernando was named a cathedral the following year.

6. A Cathedral and the White Elephant

Even before the eventual arrival of a railroad, there were hints that San Antonio would become a modern city. Observed Frederick Law Olmsted, five years before the Civil War: "Around the plaza are American hotels and new glass-fronted stores, alternating with sturdy battlemented Spanish walls and confronted by the dirty, grim old stuccoed stone cathedral, whose cracked bell is now clunking for vespers." With the end of the war in 1865, it was time for San Antonio to catch its breath and move ahead.[1]

One postwar step would be the long-awaited transformation of San Fernando into a modern church. It had not aged well. There were several fires. Damage from a blaze in 1828 was not repaired until 1841. In 1858 part of the roof collapsed, taking the choir loft and organ with it. Restructuring began ten years later under architect François Giraud. Most of the project was completed in 1873, a year before San Antonio was made the center of a new Roman Catholic archdiocese and San Fernando became its cathedral. The Spanish colonial apse, original side altars and a third of the original nave were preserved. The original dome, which had collapsed during the project, was rebuilt. The remainder of the old nave was taken down and replaced by one three times as wide and twice as long, extending over the site of the old bell tower and over the cemetery to the limits of church property. The second of the new twin bell towers was completed in 1902.[2]

North of San Fernando, Alabama native Thomas C. Frost joined his brother's mercantile and auction firm in 1866. He added wool commission business, contracting with freighters to pick up wool at sheep ranches and haul it in for storage in warehouses and, when the market rose, for sale. He began banking at the rear of the store, enlarged with a design by Alfred Giles in 1883. Four years later Frost began moving into banking fulltime. Frost National Bank, known today as Frost Bank, became San Antonio's largest financial institution. George Brackenridge's new San Antonio National Bank became a tenant in the French Building at the plaza's southeast corner in 1866. Lockwood National Bank's first home was in the four-story Kampmann Building, completed at the northeast corner in 1883.[3]

As regional trade grew, retail development on Main Plaza followed. Growth was fed from the east by the link with Commerce Street, known in the mid-nineteenth century as Main Street. Around the corner, a line of new retail buildings soon faced the plaza's east side, including the first location of Lazarus Frank's noted saddlery. Anchoring the southeast corner was the two-story French Building, built in 1858 and serving as U.S. Army headquarters from the end of the Civil War until the completion of Fort Sam Houston. At the northwest corner with Commerce Street, hardware man Carl Elmendorf and grocers Theisen & Dunlop had

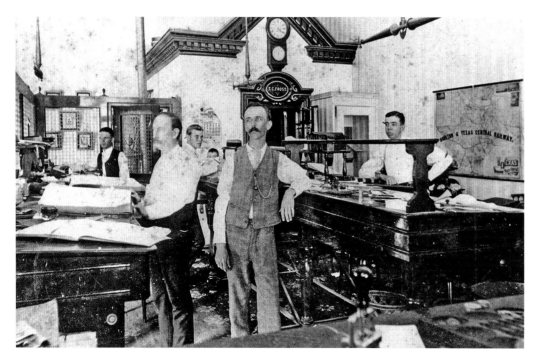

Thomas C. Frost joined his brother in the mercantile business just north of San Fernando in 1866. In 1887 he shifted to banking fulltime with a staff that included, two years later, teller Ned McIlhenny, front center, and cashier J. T. Woodhull, right.

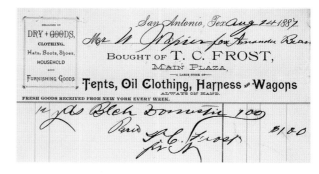

already staked out their locations. But it was Main Plaza's saloons and gambling halls, particularly those along the north side, that gained the plaza—and San Antonio—notoriety in stories of the Old West.[4]

Main Plaza had long been known for gambling. In the second quarter of the nineteenth century, tables were arranged in a quadrangle in the plaza's center, and card games "went on all night." Some play began in the morning and ended during the siesta, resuming after 3 p.m. As the crowd grew, women and men gambled openly, remembered one observer, "and, as a rule, the games were fair." Games were moved indoors only "when the wind was strong enough to blow the cards away or the rain was hard enough to wet them so the dealers could not shuffle or deal." A later writer explained: "Gambling was one of the leading local industries. Its apologists said it kept money in circulation."[5]

Main Plaza could compete with nearby Military Plaza in the rowdiness of its saloons. One notorious dive was the Bexar Exchange, on the south side of Main Plaza, where desperado John Joel Glanton once dispatched a Texas Ranger with a Bowie knife. Another was the Bull's Head, on Market Street less than a block east of Main Plaza, where money on the gambling tables was piled "profusely and abundantly."[6]

One newcomer in the mid 1870s was a noted Kansas cowtown saloonkeeper and gunfighter known as Rowdy Joe Lowe, whose wife was called Rowdy Kate. At the northeast corner of Main Plaza they operated a combination theater, saloon and gambling establishment, the Cosmopolitan. Lowe made San Antonio headlines in 1875 for assaulting his wife and was fined $100. Rowdy Joe later abandoned Rowdy Kate, moved on and eventually died in a drunken shootout in a Denver saloon.[7]

The Cosmopolitan was purchased by Jack Harris, age thirty-five, and renamed the Jack Harris Saloon and Vaudeville Theater. In 1882 Ben Thompson, city marshal of Austin, who had been banned from Jack Harris's for gambling debts, came in looking for Harris. Thompson shot Harris before Harris could fire back, and Harris died the next morning. Two years later, a drunken Thompson returned in the company of John King Fisher, age thirty, a reformed rustler who was running for sheriff of Uvalde County. Thompson wanted to make amends with the new owners, but things soon went awry. Thompson and Fisher died in a hail of gunfire. One of the owners, Joe Foster, died later from his wounds in the affray. The remaining owners sold out. The theater burned in 1886. The Elite Hotel and Restaurant was built on the site, which has gone down in Western lore as the Fatal Corner.[8]

Gamblers passing through San Antonio read like a Who's Who of the Old West. Early in the 1880s Bat Masterson was in town. So was Wyatt Earp, as he put his OK Corral gunfighting days behind him to make his living as a traveling gambler. They were no doubt attracted to San Antonio's finest emporium,

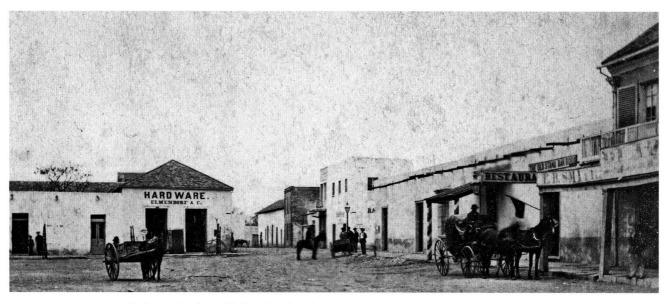

Carl Elmendorf established his hardware store at the northwest corner of Main Plaza before the Civil War. Shortly after the war, the edge of the Plaza House is pictured next to a restaurant that includes The Old Stand Bar Room.

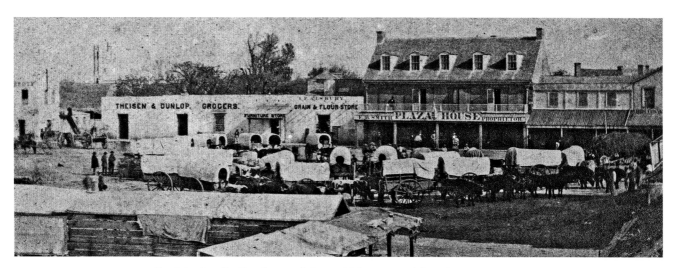

In this detail of a photo of about 1861, covered freight wagons filled Main Plaza in front of the Plaza House, built on the north side of the plaza in 1847 and San Antonio's first genuine hotel.

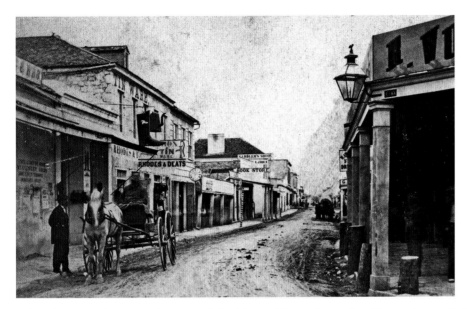

San Antonio businesses in the early 1870s marked their locations with symbols hung outdoors, as seen in this view down Commerce Street from the northeast corner of Main Plaza. A boot, above left, hangs over the entrance to a clothing store next to a pot with spout above a tin ware shop. Two doors down, a jeweler displayed the sign of a watch.

the three-story White Elephant Saloon and Gambling House, opened in 1883 on the north side of Main Plaza on the site of the Plaza House hostelry. From the polished floor of black and white marble squares and the bar—lined with mirrors of French plated glass in frames of carved mahogany—a broad stairway led up to four gambling rooms, lushly carpeted and finely furnished. But the White Elephant may have been too lavish for San Antonio, for it lasted only three years. The building was purchased by merchant Leopold Wolfson and soon disappeared as a landmark. Wolfson incorporated the structure into his adjacent store, later removed the saloon's mansard-roofed third floor and covered the exterior in the style of his own two-story building.[9]

Buffered by San Fernando Cathedral and the distance from Commerce Street, Main Plaza's southwest corner was relatively quiet—though hardly serene—and thus was a convenient a site for hotels. Hord's, later the Southern Hotel, was three stories where it faced Main Plaza and rose to four at the rear, where it opened onto Military Plaza. Over a period of thirty-some years, a nearby hostelry went through stages as the Garza House and Reed House until 1873, when it was taken over by Isaac N. Baker, a onetime Mississippi River steamboat owner and cotton planter down on his luck after the Civil War. He renamed it the Baker House, then the Central Hotel. In the 1883 he moved the Central into new quarters next door, leaving Phineas P. Lounsbery to reopen the old building as the St. Leonard, with twenty-four rooms. The St. Leonard promoted itself as "one of the leading hotels in southwest Texas," though latter-day archeological excavations turned up layers of artifacts sufficiently mediocre to suggest that the hotel "may not have been as opulent" as its promotion materials suggested.[10]

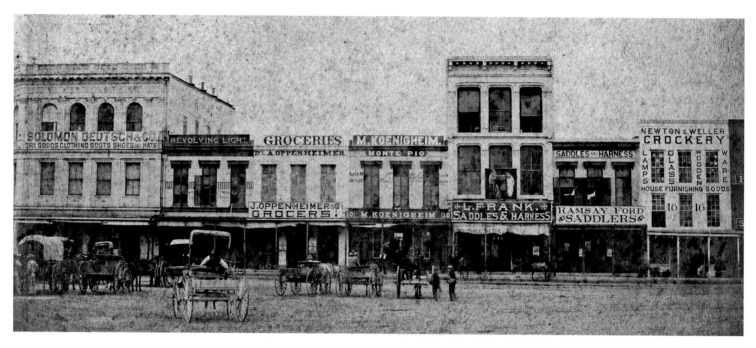

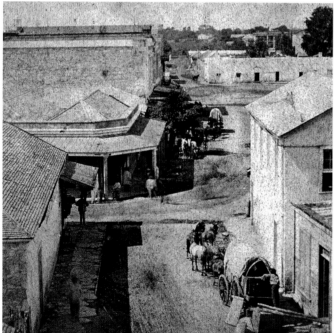

A row of businesses fronting Main Plaza on the east includes an ever-present saloon, this one named the Revolving Light. Below a large painting of a saddle is the sign of Lazarus Frank, whose firm became one of San Antonio's best-known makers of saddles and leather goods.

A telephoto lens compressed the view south along Soledad Street past the Commerce Street corner and into Main Plaza to the low building which became the site of the Bexar County Courthouse. Appearing above is the columned façade of the Vance House.

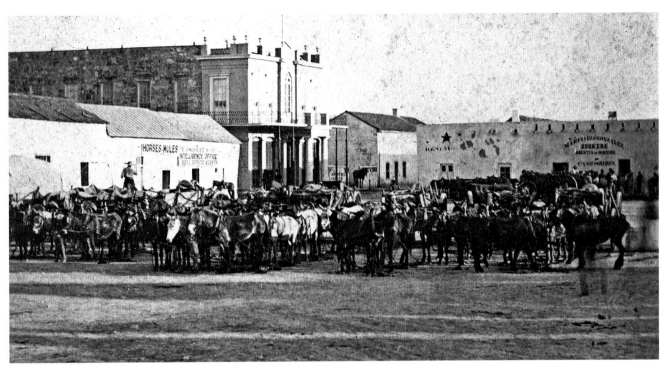

Four wagons each drawn by teams of eight mules are lined up in the southeast corner of Main Plaza in about 1870, when the two-story French Building at left center was the U.S. Army's headquarters in Texas. The building to its right, on Dwyer Avenue, served as the post office.

The city's landmark Greek Revival style market house shows at the left in this view looking east on Market Street from Main Plaza. To the right of the market house, bearing the sign of the bull above the door, is the storied Bull's Head Saloon.

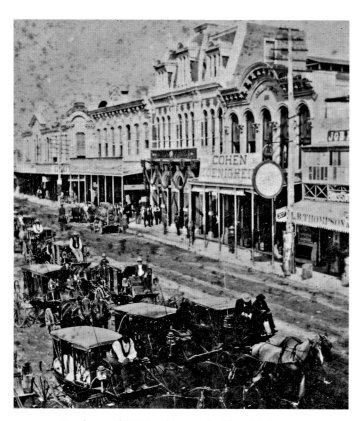

By the mid 1880s the north side of Main Plaza was lined with elegant storefronts and the elaborate three-story White Elephant Saloon, center, which replaced the Plaza House.

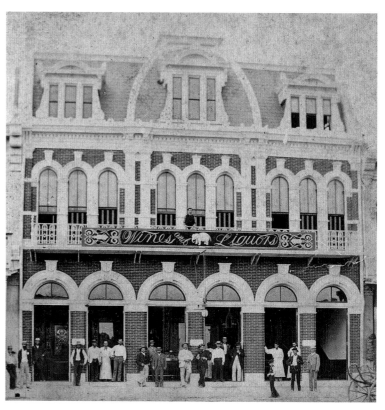

The White Elephant Saloon, with polished marble floors, a mirror-lined bar and plush game rooms, opened in 1883 to serve gamblers like Bat Masterson and Wyatt Earp who were passing through town.

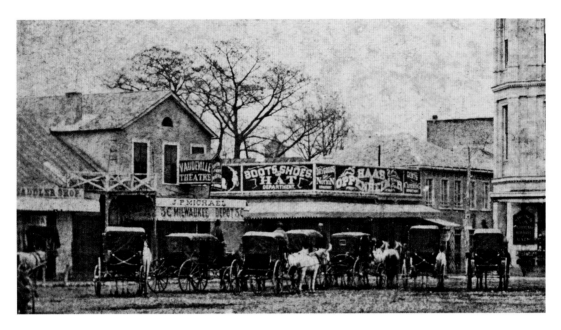

Carriages were waiting for fares in northeastern Main Plaza by 1880, when the Vaudeville Theater stood at the northwest corner of Commerce and Soledad streets. Numerous shootings in the theater caused the site to become known as the Fatal Corner.

When the White Elephant closed in 1887, Leopold Wolfson incorporated the building into his adjoining mercantile operation.

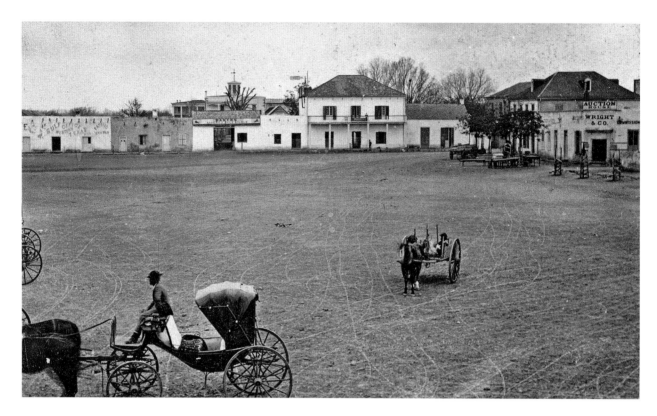

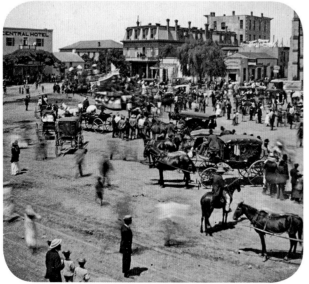

The southwest corner of Main Plaza was dominated in the early 1870s by the two-story Baker House. To the left is the hotel's livery stable. Looming behind are the Nueva Street homes of merchant James Vance and, with the cupola, of banker William G. Bennett. At far left is the regional office of the Gulf, Western Texas and Pacific Railway, which offered a stagecoach connection from San Antonio to its nearest rail link, at Cuero.

An unidentified event in about 1880 drew a crowd to Main Plaza. The building with the mansard roof at top center is the Southern Hotel.

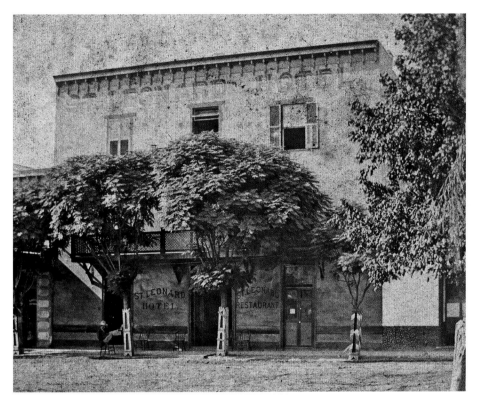

A lone figure props his feet against a shelter protecting a tree at the St. Leonard Hotel, the latest in a succession of hostelries on the site dating from the 1840s.

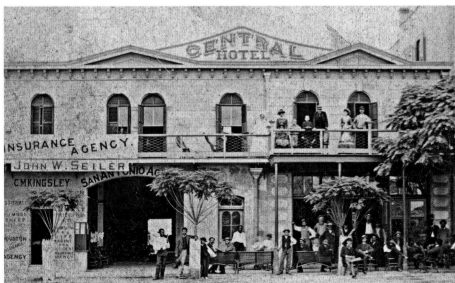

Proprietors of the Central Hotel left their old building to become the St. Leonard Hotel and built a new Central Hotel next door.

• III •
ALAMO PLAZA

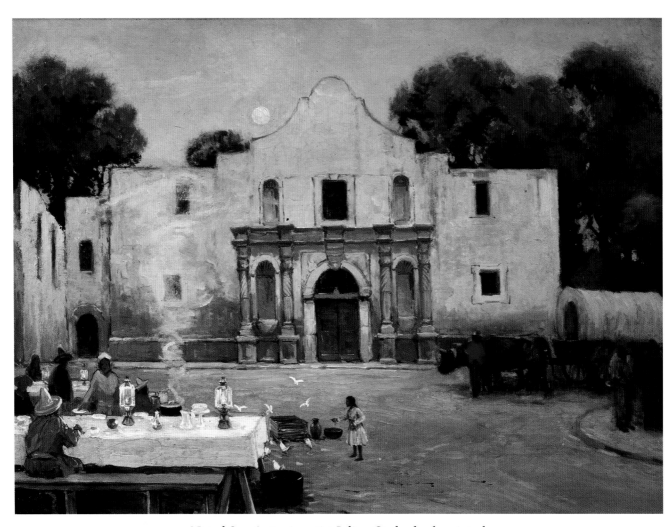

Noted San Antonio artist Julian Onderdonk painted
Chili Queens at the Alamo in oil on canvas.

7. Battlements and Barbed Wire

What was left of Alamo Plaza's Spanish mission walls disappeared by the mid nineteenth century, its stones scrounged to help build the low houses dotting the plaza's fringes. The perimeter walls were meant to keep marauding Apaches and Comanches outside the plaza of Mission San Antonio de Valero, situated on a bluff on the far side of the San Antonio River from the main town a half mile to the west. The mission's most distinctive structure was its church, begun in 1744 but still not completed above its first level when the mission closed in 1793.

Ten years later, a Spanish cavalry troop from Alamo de Parras moved up to the old mission. It became known as the Alamo Company and its post as the Alamo. Its walls were a valued refuge during the coming years, most famously for Texans annihilated there by a Mexican army on March 6, 1836. Nine years later, as Texas was annexed by the United States, the U.S. Army turned the compound into a quartermaster depot, adding the iconic gabled parapet to screen the peak of the roof put on in 1850. It was taken over by the Confederate Army during the Civil War, then reoccupied by the U.S. Army until Fort Sam Houston was finished in 1879. The wholesale grocer who moved in added wooden battlements to the two-story building next to the Alamo church, which passed to state ownership as a landmark.

But Alamo Plaza was still a backwater. "Two blocks from the site of the Menger Hotel you could shoot plenty of quail," one former resident recalled. Closer in, Frederick Law Olmsted in 1856 described the plaza as lined with "windowless cabins of stakes, plastered with mud and roofed with river-grass (or 'tula') or low, windowless but better-thatched houses of adobes (gray, unburnt bricks). . . . The principal part of the town lies within a sweep of the river upon the other side." There was, nevertheless, a steady stream of visitors. As one writer put it in 1873: "The Alamo is the shrine to which every pilgrim to this strange corner of America must do utmost reverence."[1]

There were advantages to the isolation. With the commotion those staying at hotels on Main and Military plazas had to endure, German immigrant William Menger sensed that many travelers would pay a little more to stay in a good hotel in a quiet neighborhood. At the southeast corner of Alamo Plaza he opened, in 1859, the relatively luxurious fifty-room Menger Hotel.

In the same year the city built its new market house on Market Street, close to Main Plaza. But there was little refrigeration, and the odors of fresh meat attracted hordes of flies especially unwelcome near the center of town. So the city built a separate meat market where there were few people—in the middle of nearly deserted center of Alamo Plaza, a safe distance from the new Menger Hotel. A youth growing up in the neighbor-

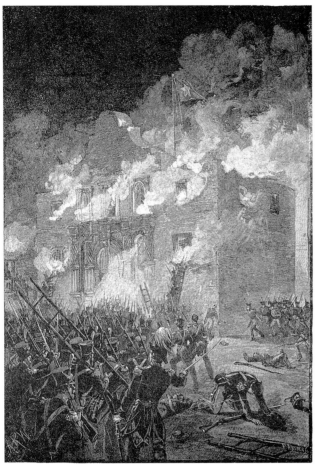

The Battle of the Alamo had become so legendary by the end of the nineteenth century that the artist of this engraving felt free to add dramatic smoke from a second story that did not exist and to include a gabled parapet that was not added until fourteen years after the battle.

hood was Ed Friedrich, who would establish a company that became one of the world's largest manufacturers of commercial refrigeration equipment. Friedrich recalled that work at the meat market started at night: "Butchers would bring meat in at dark, have it cut up about two o'clock in the morning and start selling it at 5 a.m. The flies were so bad they closed at seven in the morning; they gave away all [the] unsold meat."[2]

A writer for *Harper's New Monthly Magazine* had a more romantic take on the scene: "The sharpening of the butchers' cleavers at the meat market on Alamo Plaza is like the clashing of an army of sabers, and suggests to the dreamers the apparition of the heroic ghosts of the Alamo hard by, and their onset and shock of battle."[3]

Alamo Plaza's openness also made it ideal for an event that helped shape the future of the American West. A group of cattlemen was meeting in San Antonio in 1876. Barbed wire salesman John W. Gates decided to overcome general disbelief in his product's effectiveness by proving it to them right in town.

"At that time, Alamo Plaza was a mudhole," remembered Gates associate Pete P. McManus. "Mr. Gates and I set up the posts and strung four strands of barbed wire, making a corral of considerable size. Some of the cowboys were skeptical, and Gates and I were jollied a good deal as we went about our work of preparing for the test. A bunch of range cattle were driven into the corral and the ranchmen expected to see them go through or over the fence, but the wires held them without any trouble." McManus—and many others—believed that this first notable demonstration of barbed wire launched the rapid spread of barbed wire fences, critical to organizing the open range and thus doing "more to civilize and develop the Southwest and West than any other influence."[4]

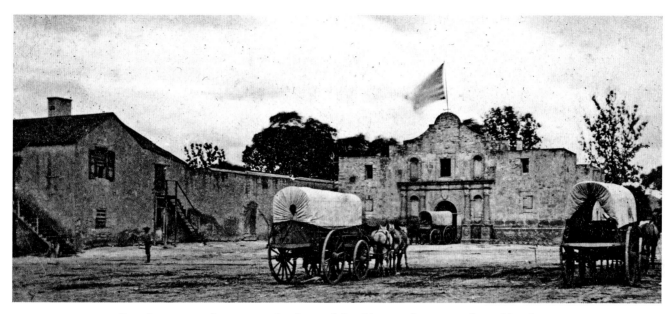

Supply wagons drew up to the door of the Alamo when it was leased by the
U.S. Army as a quartermaster depot for San Antonio and the Texas frontier.

The turning point for Alamo Plaza came with news that the new San Antonio Street Railway would begin mule-drawn streetcar service in 1878 between Alamo Plaza and San Pedro Springs, nearly two miles across town to the northwest. The nearly deserted space at the far edge of downtown would be accessible to all. There was no shortage of real estate awaiting development.

Alamo Plaza's frontier landscape seemed to explode with commercial and civic development. The post office moved from just off Main Plaza to Alamo Plaza's new Gallagher Building (1877). The three-story Crockett Block (1882) was built on the west side. To its north, on the corner with Houston Street, the younger Samuel Maverick's Maverick Bank (1885), its balconies of elaborate iron grillwork, rose to five stories, ranking it as the tallest building in the city and, residents believed, the tallest west of the Mississippi. Not far down the block was the turreted Opera House (1886). The Menger Hotel enlarged along its north side (1887). German immigrant Julius Joske, who opened his first dry goods store on Main Plaza in 1867, moved near Alamo Plaza and then into a new building (1888) that expanded across the southern end of the plaza. Joske's became one of the largest department stores in Texas.

Alamo Plaza may have leaped ahead of Military and Main plazas as a commercial center, but by 1890 the entire town seemed to be growing and changing just as quickly. San Antonio's frontier era was over.

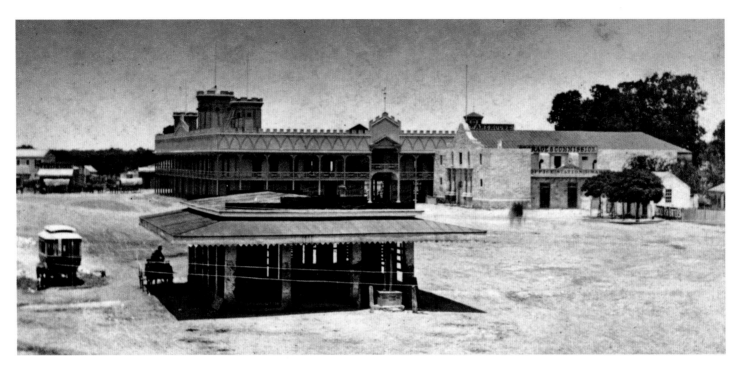

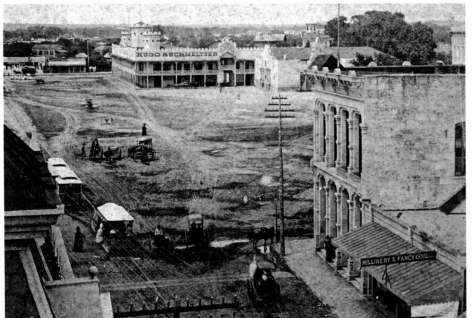

Wooden battlements enclose the building adjoining the Alamo church while the complex was a grocery warehouse, forming the backdrop for a mule-drawn streetcar stopped near the open-air meat market run by the city in the middle of the mostly deserted plaza. The Menger Hotel was built off the view at the right.

By the mid-1880s the meat market was gone from the center of Alamo Plaza as new development began. At lower right, the two-story Gallagher Building, built in 1877, housed the U.S. Post Office, which moved from Main Plaza.

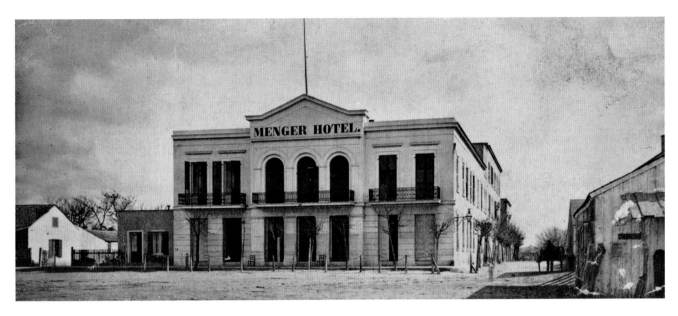

German immigrant William Menger built San Antonio's finest hotel at the southeast corner of Alamo Plaza in 1859. After his death, his widow continued its operation and still imported the finest foods for guests.

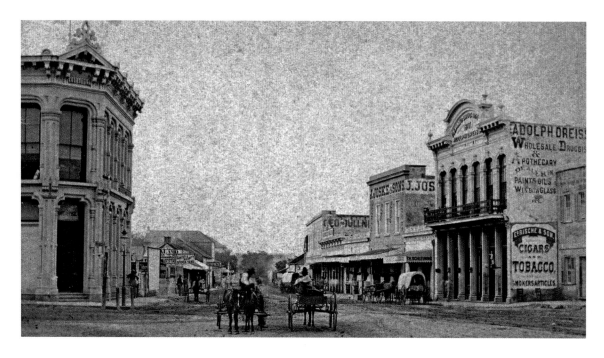

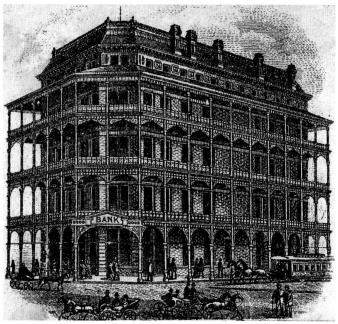

Among the retail firms opening near Alamo Plaza in the 1870s and 1880s was Julius Joske & Sons, right center, just beyond the plaza's west side. The store later moved across the street, bought surrounding property and became one of the largest department stores in Texas.

In 1885 the five-story Maverick Bank was built at the northwest corner of Alamo Plaza with elaborate iron balconies. It became the tallest building in San Antonio and, many thought, the tallest building west of the Mississippi.

Landscaping in 1890 brought a new measure of conformity with other cities to the once dusty expanse of Alamo Plaza. It reflected the continuing trend to modernization that would soon add trendy landmarks like the turreted Opera House at center right to replace the rest of the ramshackle if colorful structures that once lined the frontier plaza. The Alamo and the Menger Hotel are off the view at the left.

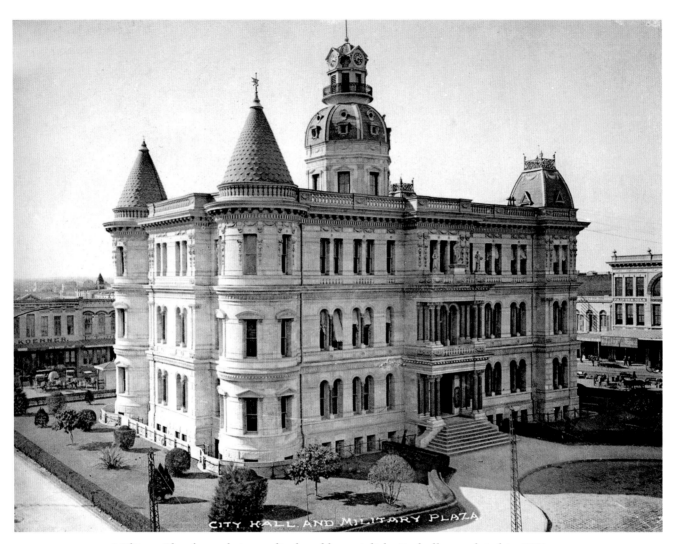

CITY HALL AND MILITARY PLAZA

Military Plaza's market was displaced by a stylish city hall completed in 1891 in the center of the plaza. A few vendors can still be seen around the far edges in this view from the early 1900s. The turrets and clock tower were removed in 1927, when City Hall gained a fourth story and its exterior was redesigned.

Epilogue

The appearance of San Antonio's Spanish plazas changed abruptly in the few years before and after 1890.

Main Plaza's San Fernando Cathedral, its bell tower once the city's tallest landmark, was overshadowed in 1896 by the granite and red sandstone Bexar County Courthouse, its beehive spire seven stories high. On Alamo Plaza, the boom of the 1880s climaxed in 1891 with a landmark federal building and post office of gray stone, in the Richardson Romanesque style so popular in other American cities. Its castlelike turret suggested a fortress more elaborate than the Alamo. Also in 1891, a three-story Second Empire city hall, in white limestone with round or square turrets on each corner and crowned by an elaborate clock tower, opened in the center of Military Plaza. A year earlier, the San Antonio Street Railway changed its mule-drawn cars to ones powered by electricity.

Change in the landscape coincided with San Antonians' desire to become a metropolis. As hordes of newcomers made San Antonio the largest city in Texas, the old order retreated. Observed one writer: "Almost overnight, the turbulence of the frontier left San Antonio. The last herd of cattle went up the Chisholm Trail in 1895. The cowboys, the highwaymen, the diamond-breasted gamblers all departed.[1]

The open, dusty centers of Alamo and Main plazas gave way to the sort of parklike landscapes and shaded walkways popular elsewhere. But nowhere was transformation more evident than on Military Plaza, where the new city hall displaced the colorful, little regulated open-air market. Gone was the original city hall known as the Bat Cave, for the previous forty years tucked discreetly in the plaza's northwest corner. Vendors were still permitted around the plaza, but with restrictions. They were kept at its edges by the new city hall's fifteen-foot perimeter of con-

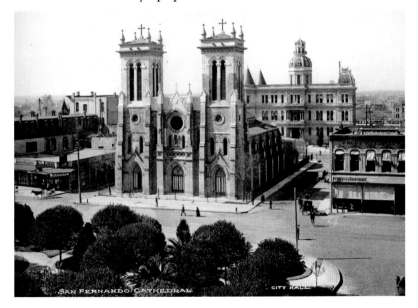

A stylish city hall and completion of San Fernando's second tower in 1902 reflect the new era.

89

crete pavement and surrounding fifty-foot skirt of new grass, interrupted only by a curving carriage driveway from the street[2]

The Military Plaza market was in part a victim of its own success. It was more convenient for shoppers than the municipal market house off Main Plaza on narrow Market Street, its prices were often lower and the city's market house revenues were declining. In 1888, as planning for the new city hall was getting under way, Military Plaza was officially designated a public market. Hours were set, spaces assigned and fees levied. Eleven years later the city built a commodious new market house three blocks west, near Milam Park. In 1901, with sanitary concerns a factor, street sales of vegetables and farm produce were banned within five blocks of the new market house, a radius that happened to include Military Plaza.[3]

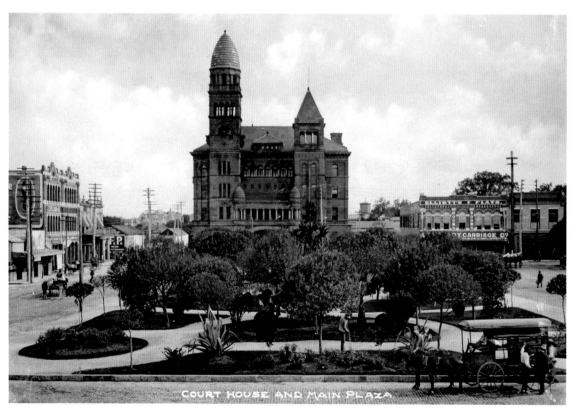

The Bexar County Courthouse was completed in 1896 on newly landscaped Main Plaza. At its right, Elliott's Flats had replaced the old Central Hotel. San Fernando is off the view at the right.

90

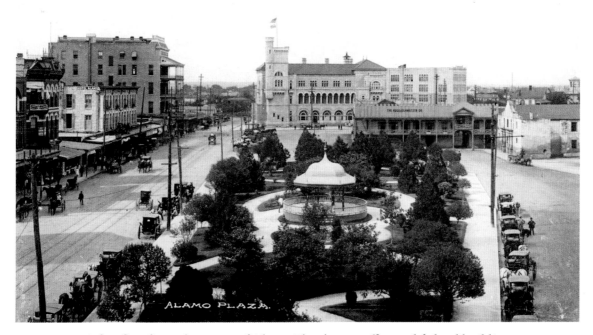

A flag flies from the turret of Alamo Plaza's post office and federal building, finished in 1891. To its left is the five-story Maverick Bank Building, and at left center is the three-story Crockett Block, which survives. To the left of the Alamo, the old Spanish mission building then serving as a wholesale grocery was yet to lose its second story. Carriages at the lower right await fares from the Menger Hotel, out of view at the right.

Some vendors had remained on Military Plaza for a while, and chili stands hung on for a few more years around Alamo Plaza. Most chili stands moved west of San Pedro Creek around Haymarket Square, where increasingly restrictive health regulations finally eliminated them in 1937. Six years later health officials banned them anywhere in the city. In 1947 the San Antonio Conservation Society revived chili stands as a signature feature of its A Night in Old San Antonio, now a blocks-wide, four-night Fiesta food event attracting a hundred thousand visitors each spring. These days the chili queens wear sanitary thin plastic gloves.[4]

The three Spanish plazas were still evolving. Alamo Plaza's 1891 post office and federal building had been replaced in 1937 by one even larger, of five stories faced by white limestone in an elegant neoclassical style. South of the Alamo, turned into a shrine of Texas liberty, the Menger Hotel retained its historic original section. Across the way, old retail buildings tended toward use as wax museums and halls of wonder.

Main Plaza's San Fernando Cathedral and Bexar County Courthouse both underwent restorations, while the plaza itself was transformed in 2006. Streets on its east and west sides were closed as the plaza became an imaginatively designed pedestrian space. A new facility for San Fernando rose on the parking lot that had once been the site of the Southern Hotel. On the plaza's east side, where only one older building remained, a landscaped park led down to the River Walk along the flood control channel dug east of the plaza in the 1920s. At the northwest corner, the former twelve-story Frost National Bank (1922) became an annex to city hall known as the Municipal Plaza Building and included council chambers.

The 1891 city hall in Military Plaza kept offices of the mayor and others, though the building was unrecognizable from its original form. In 1927 the clock tower and four corner turrets were removed for a fourth story, and the entire exterior was reclad in Spanish Colonial Revival style. Parking areas beside city hall were later expanded and connected to the west side of Military Plaza, further obscuring its identity as a once-open plaza.

Visibly changed though San Antonio's Spanish plazas may be, all retain significant landmarks and functions from Spanish times. Residents still worship, as intended, at Main Plaza's San Fernando Cathedral, and some of its elements remain from the church of 1755. The Casas Reales, the seat of civil gov-

 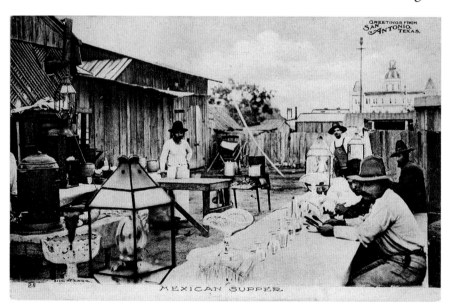

Basket vendors still roamed the streets and plazas as the new postcard industry delighted tourists with views of the last chili stands, including those, right, west of San Pedro Creek beyond Military Plaza's City Hall, which appears in the distance at right.

ernment established across Main Plaza, may be gone, but San Antonio's civil government still functions on the plaza, both at the Bexar County Courthouse and in the Municipal Plaza Building. There may no longer be a garrison on Military Plaza but the presidio captain's house remains, restored in 1930 as the Spanish Governor's Palace. On Alamo Plaza there are no priests at the one-time Mission San Antonio de Valero, but the Alamo—its unfinished church—has become one of the top travel destinations in Texas.

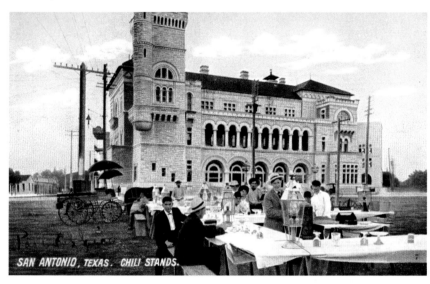

SAN ANTONIO, TEXAS. CHILI STANDS.

Alone among the largest U.S. cities of Spanish origin, San Antonio, especially through its plazas, still harks back, significantly, to Spanish times.[5]

Mexican Candy Seller, San Antonio, Tex.

Alamo Plaza's last chili stands seem a bit forlorn and out of sync with the times with their new backdrop, the 1891 post office and federal building. Nearby, an aging candy seller gamely stands ready to whisk away flies or bees while waiting for a buyer at his post in front of the Alamo.

Credits

Bexar County—62–63 (all)

Dolph Briscoe Center for American History, University of Texas at Austin (Charles Adelbert Herff Remiscences)—19

William Corner, *San Antonio de Bexar*—3

Daughters of the Republic of Texas Library at the Alamo—16, 33 (below), 37 (top right, Ramsdell Collection), 41, 56, 59, 60, 70 (below), 72 (top), 87 (Aniol Collection)

DeGolyer Library, Southern Methodist University, Dallas, Texas—Lawrence T. Jones III Texas Photography Collection–9, 23 (right), 26 (below), 31 (right), 37 (top left), 39, 85 (top); Album of Views of Arizona, New Mexico and the Southwest 1892–29 (top)

Lewis F. Fisher—7, 20, 22, 24–25, 27, 29 (below), 34 (top left), 36 (below), 37 (top center), 38, 40, 45, 46, 49, 50, 51, 68 (right), 73 (top), 74 (right), 75 (below), 77, 82, 83, 84 (below), 85 (below), 86 (below), 88–93

Frost Bank Historical Archives—68 (left, both)

Lawrence T. Jones III—36 (top center), 76 (top)

Frank Leslie's Illustrated Newspaper—17, 18 (Jan. 15, 1859); 65 (Mar. 23, 1861)

San Antonio Conservation Society Foundation (Raba Collection)—32 (right)

San Jacinto Museum of History, Albert and Ethel Herzstein Library—64

Helen James Schupbach—12, 30

Robin Stanford—4, 6, 8, 14, 23 (left), 26 (top), 28 (both), 31 (left), 32 (left), 33 (top, both), 34 (top right, below), 36 (top right), 43, 44 (both), 48, 52, 53, 57, 66, 70 (top), 71, 72 (below), 73 (below), 75 (top), 76 (below), 84 (top), 86 (top)

University of Oklahoma Western History Collections (Noah H. Rose Collection)—47

University of Texas at San Antonio Libraries, Special Collections—42

Witte Museum—ii, 2, 35 (both), 36 (top left), 37 (below), 74 (left), 80

Identified Photographers

A.F. Dignowity—85 (top)

Henry A. Doerr—6, 7, 22, 28 (below), 32 (left), 33 (top left), 36 (top, all), 37 (top, left and center), 57, 70 (top), 71, 72 (below), 73 (both), 76 (below), 83, 84 (top), 86 (top)

Doerr & Jacobson—4, 8, 34 (top left), 76 (top)

S. E. Jacobson—29 (top), 30, 35 (top)

Alexis V. Latourette—36 (below)

Frank Hardesty—20, 24–25, 26 (both), 27 (left), 31 (both), 33 (top right), 34 (below), 39, 40, 43, 45, 53, 66, 74 (right), 77 (both), 84 (below)

John A. G. Rabe—33 (below), 72 (top)

Eugenio K. Sturdevant—23 (left), 37 (below), 44 (both)

Nicholas Winther—27 (right)

Notes

INTRODUCTION: TOWN PLAZAS FOR NEW SPAIN

1. Gould, *The Alamo City Guide,* 138.
2. Cox, *The Spanish Acequias of San Antonio,* 14, 34–36. The Villa of San Fernando de Béxar ranked midway in the Spanish hierarchy of settlements—Ciudad, Villa and Pueblo.
3. Olmsted, *A Journey Through Texas,* 150, 158–59.
4. The definitive work on the subject is *Catching Shadows: A Directory of 19th-Century Texas Photographers* by San Antonian David Haynes.
5. Haynes, *Catching Shadows,* 48; Morrison and Fourmy, *General Directory,* 171; *San Antonio,* Sanborn Map, July 1885. In addition to details on the backs of Hardesty's cards, there are notes on Hardesty in the New York Public Library's Photography Collection.

1. GARRISON GROUND TO PLAYGROUND

1. Bushick, *Glamorous Days,* 96.
2. Ivey, "A Reconsideration of the Survey," 255, 258–59. Ivey notes that only the front rank of rooms dates from Spanish Colonial times.
3. Everett, *San Antonio: The Flavor of its Past,* 7.
4. "Casas Revolt," Tyler, ed., *New Handbook of Texas,* I, 1009–10; Antonio Menchaca, *Memoirs,* San Antonio: Yanaguana Society, 1937, 13; Hafertepe, "The Romantic Rhetoric of the Spanish Governor's Palace," 242, 276–77.
5. Rogers, "A History of the Military Plaza," 16–17, 45. Perhaps because of being known as the "Bat Cave," San Antonio's 1851 city hall has drawn little attention in surveys of San Antonio's early architecture. It was, in fact, according to an assessment by Bruce MacDougal, an architectural historian and director of the San Antonio Conservation Society, "actually an architecturally sophisticated public edifice. Of masonry construction, the two-story 1850 building displayed classical features such as rusticated quoins at the corners and a belt course between the first and second stories. Like many of the contemporary residential structures of the time in San Antonio, large wooden casement windows, when opened inward behind louvered shutters, would permit the greatest volume of cooler air to enter the interior. The hipped roof, which was consistent with other architecture of the period, gave added interest to the building by flaring out above the eaves."
6. Rogers, "A History of the Military Plaza," 19, 36, 60. Few fandangos were held after the early 1870s.
7. Newcomb, *The Alamo City,* 79.
8. Everett, "Things In and About San Antonio," 95–96, 102–03.
9. Everett, "Things In and About San Antonio," 102; Barnes, *Combats and Conquests,* 118; Rogers, "A History of the Military Plaza," 37.
10. Everett, *San Antonio Legacy,* 31–38.

2. MARKET DAY

1. Rogers, "A History of the Military Plaza," 35; Barnes, *Combats and Conquests,* 118.
2. Rogers, "A History of the Military Plaza," 32–33.
3. Gould, *The Alamo City Guide,* 138.

4. Rogers, "A History of the Military Plaza," 27–30.

5. Everett, *San Antonio: The Flavor of its Past*, 34.

6. Everett, *San Antonio: The Flavor of its Past*, 33–34; Gould, *The Alamo City Guide*, 138.

3. The Chili Queens Reign

1. Rogers, "A History of the Military Plaza," 28, 30.

2. Martinello, *The Search for a Chili Queen*, 48–49.

3. Rogers, "A History of the Military Plaza," 48–49.

4. Pilcher, "Who Chased Out the Chili Queens?," 178.

5. Bushick, *Glamorous Days*, 99.

6. Bushick, *Glamorous Days*, 98.

7. Bushick, *Glamorous Days*, 98; Rogers, "A History of the Military Plaza," 51.

4. Around the Plaza

1. "The Military Plaza," *San Antonio Express*, March 16, 1876, 2; Rogers, "A History of the Military Plaza," 24–25, 31.

2. Rogers, "A History of the Military Plaza," 65, 67–68, 70.

3. Rogers, "A History of the Military Plaza," 19, 56; Fisher, *Saving San Antonio*, 70.

4. Bowser, *West of the Creek*, 13–15; Bushick, *Glorious Days*, 202; Rogers, "A History of the Military Plaza," 55, 57; Matthews and Fourmy, *General Directory of the City of San Antonio*, 1887–1888, 55.

5. Martinello, *The Search for a Chili Queen*, 61–77.

5. A Plaza for the Villa

1. Benavides, "Sacred Space," 11–19.

2. Teja, *San Antonio de Béxar, 39–40.*

3. Maverick, *Memoirs*, 40–41.

4. Barnes, *Combats and Conquests*, 121.

5. Lewis F. Fisher, *Saint Mark's Episcopal Church: 150 Years of Ministry in Downtown San Antonio, 1858–2008*, San Antonio: Maverick Publishing Co. (2008), 13.

6. William Edward Dunn, "Apache Relations in Texas, 1718–1750," *The Quarterly of the Texas State Historical Association* 14:3 (Jan. 1911), 260–62.

7. Maverick, *Memoirs*, 23.

8. Goetzmann, *Sam Chamberlain's Mexican War*, 45.

6. A Cathedral and the White Elephant

1. Olmsted, *A Journey Through Texas*, 150.

2. Benavides, "Sacred Space," 11–19.

3. Mason, *A Century on Main Plaza*, 16–22, 33, 38.

4. Steinfeldt, *San Antonio Was*, 40, 105, 121.

5. Everett, *San Antonio Legacy*, 39–40; Bushick, *Glamorous Days*, 107.

6. Bowser, *West of the Creek*, 6–7; Everett, *San Antonio Legacy*, 41.

7. Bowser, *West of the Creek*, 11–12.

8. Bowser, *West of the Creek*, 17–22.

9. Bowser, *West of the Creek*, 4, 5.

10. Steinfeldt, *Art for History's Sake*, 243; Hanson, "The Archaeology of San Antonio's Main Plaza," 36, 92.

7. Battlements and Barbed Wire

1. Steinfeldt, *San Antonio Was*, 52; Olmsted, *A Journey to Texas*, 119; "Glimpses of Texas—I: A Visit to San Antonio," *Scribner's Magazine*, 1873, 322.

2. Woolford, *The San Antonio Story*, 89.

3. Harriet Prescott Spofford, "San Antonio de Bexar," *Harper's New Monthly Magazine*, November 1877, 836.

4. Everett, *San Antonio Legacy*, 19–22.

Epilogue

1. Peyton, *San Antonio: City in the Sun*, 51.

2. *San Antonio Daily Express*, Sept. 4, 1891, 8. San Antonio's models for improvement apparently extended beyond the United States. Reported the *Daily Express*: "One pronounced policy of the new administration inaugurated with the return of Mayor Callaghan from Paris is the improvement of parks and squares."

3. Rogers, "A History of the Military Plaza," 32–34.

4. Pilcher, "Who Chased out the 'Chili Queens'?", 192–94; Fisher, *Saving San Antonio*, 133, 350. Popularity of chili con carne may very well have spread to the rest of the nation thanks to tourists who first encountered it in San Antonio. But the oft-repeated, undocumented assertion that it spread nationwide after being served by immensely popular chili queens at an official "San Antonio Chili Stand" at the 1893 World's Columbian Exposition in Chicago appears to be a myth. Gustavo Arellano notes in *Taco USA: How Mexican Food Conquered America* (New York: Simon & Schuster, 2012, 34–35) that "no contemporary account of the scene exists." The distinguished historian Hubert Howe Bancroft "made no mention of any chili" in his thousand-page account of the exposition, nor did the official exposition cookbook carry any chili recipes—though it did include Mexican food recipes from New Mexico; the Texas submission was for almond blanc mange. In any event, Arellano writes, "newspapers in Washington, D.C. and Hawaii were already advertising the dish in the 1880s."

5. The comparison is with the other largest U.S. cities also designated as villas: San Francisco, Los Angeles, San Diego, Albuquerque and Tucson. None functions as completely as San Antonio according to its original Spanish colonial plan. Two have some landmarks from that time, Albuquerque its Spanish church (1706) on its historic Spanish square and San Francisco its presidio commander's home on the former Presidio military reservation outside the old city center. Otherwise, old plazas in the five cities no longer have landmarks or functions from the Spanish era. (Fisher, *Saving San Antonio*, 14, 35.)

Bibliography

Barnes, Charles Merritt. *Combats and Conquests of Immortal Heroes.* San Antonio: Guessaz & Ferlet Company, 1910.

Benavides, Adán. "Sacred Space, Profane Reality: The Politics of Building a Church in Eighteenth-Century Texas." *Southwestern Historical Quarterly* CVII 1 (July 2003), 1–33.

Bowser, David. *West of the Creek: Murder, Mayhem and Vice in Old San Antonio.* San Antonio: Maverick Publishing Co., 2003.

Bushick, Frank H. *Glamorous Days in Old San Antonio.* San Antonio: Naylor Company, 1934.

Corner, William. *San Antonio de Bexar.* San Antonio: Bainbridge & Corner, 1890.

Cox, I Waynne. *The Spanish Acequias of San Antonio.* San Antonio: Maverick Publishing Co., 2005.

Everett, Donald E. *San Antonio: The Flavor of Its Past.* San Antonio: Trinity University Press, 1975.

_____. *San Antonio Legacy: Folklore and Legends of a Diverse People.* San Antonio: Maverick Publishing Co., 1999.

Everett, Richard. "Things In and About San Antonio." *Frank Leslie's Illustrated Newspaper* VII 163 (Jan. 15, 1859), 97–103.

Fisher, Lewis F. *San Antonio: Outpost of Empires.* San Antonio: Maverick Publishing Co., 1997.

_____. *Saving San Antonio: The Precarious Preservation of a Heritage.* Lubbock: Texas Tech University Press, 1996.

Goetzmann, William H. *Sam Chamberlain's Mexican War: The San Jacinto Museum of History Paintings.* Austin: Texas State Historical Association for the San Jacinto Museum of History, 1993.

Gould, Stephen. *The Alamo City Guide.* New York: Macgowan & Slipper, Printers, 1882.

Hafertepe, Kenneth. "The Romantic Rhetoric of the Spanish Governor's Palace, San Antonio, Texas." *Southwestern Historical Quarterly* CVII (October 2003), 239–77.

Hanson, Case Jeffrey. "The Archaeology of San Antonio's Main Plaza, Investigations at 41BX1753." Master's thesis, University of Texas at Austin, 2010.

Haynes, David. *Catching Shadows: A Directory of 19th-Century Texas Photographers.* Austin: Texas State Historical Association, 1993.

Ivey, James E. "A Reconsideration of the Survey of the Villa de San Fernando de Béxar in 1731." *Southwestern Historical Quarterly* CXI 3 (January 2008), 251–81.

Martinello, Marian L. *The Search for a Chili Queen: On the Fringes of a Rebozo.* Fort Worth: Texas Christian University Press, 2009.

Mason, Herbert M. Jr., with Frank W. Brown. *A Century on Main Plaza: A History of the Frost National Bank.* San Antonio: Frost National Bank, 1968.

Maverick, Mary A. *Memoirs of Mary A. Maverick: A Journal of Early Texas.* Rena Maverick Green and Maverick F. Fisher, eds. San Antonio: Maverick Publishing Co., 2005.

Morrison and Fourmy. *General Directory of the City of San Antonio, 1887–1888.* Galveston: Morrison & Fourmy, 1886.

Newcomb, Pearson. *The Alamo City.* San Antonio: Standard Printing Company, 1926.

Olmsted, Frederick Law. *A Journey Through Texas.* New York: Dix, Edwards & Co., 1857.

Peyton, Green. *San Antonio: City in the Sun.* New York: Whittlesey House, 1946.

Pilcher, Jeffrey M. "Who Chased Out the 'Chili Queens?' Gender, Race and Urban Reform in San Antonio, Texas, 1880–1943." *Food and Foodways: Explorations in the History and Culture of Human Nourishment* 16:3 (2008), 173–200.

Rogers, Will C. III. "A History of the Military Plaza to 1937." Master's thesis, Trinity University, 1968.

San Antonio, Texas. New York: Sanborn Map and Publishing Co., December 1877, July 1885, October 1888.

Spofford, Harriet Prescott. "San Antonio de Bexar," *Harper's New Monthly Magazine*, November 1877, 831–49.

Steinfeldt, Cecelia. *Art for History's Sake: The Texas Collection of the Witte Museum.* Austin: Texas State Historical Association for the Witte Museum of the San Antonio Museum Association, 1991.

_____. *San Antonio Was: Seen Through a Magic Lantern.* San Antonio: San Antonio Museum Association, 1978.

Teja, Jesús F. de la. *San Antonio de Béxar: A Community on New Spain's Northern Frontier.* Albuquerque: University of New Mexico Press, 1995.

Tyler, Ron, ed. *The New Handbook of Texas.* Austin: Texas State Historical Association, 1996. 6 vols.

Woolford, Sam and Bess. *The San Antonio Story.* San Antonio: Joske's of Texas, 1950.

Index